PRIVATE PICTURES

PRIVATE PICTURES

Introduced by Anthony Burgess

Photographs by Daniel Angeli
and Jean-Paul Dousset

JONATHAN CAPE
THIRTY BEDFORD SQUARE LONDON

First published 1980
Introduction copyright © 1980 by Anthony Burgess
Photographs copyright © 1980 by Daniel Angeli Agency
Jonathan Cape Ltd, 30 Bedford Square, London WC1

British Library Cataloguing in Publication Data

Angeli, Daniel
Private pictures.
1. Portraits
I. Title II. Dousset, Jean-Paul
920'.0022'2 CT206

ISBN 0 224 01846 9
ISBN 0 224 01883 3 Pbk

Printed in Italy by A. Mondadori Editore, Verona

INTRODUCTION

Ladies and gentlemen, meet, as they say, the stars. But not the stars in conscious glory, desperately shining. The stars off their guard; the stars naked – sometimes literally so. Charlie Chaplin near to death, Frank Sinatra fat and yawning, Bardot adroop, Elizabeth Taylor dumpy but happy, Tony Armstrong-Jones miserable. And others. You will notice that the term 'star' has taken on a wider meaning than it possessed in the old days, when it was reserved to stage and especially screen performers. You can be a star movie director, a star photographer, a star royal. Or you can, like Jacqueline Kennedy Onassis, be a star widow. You don't necessarily have to *do* anything. If your name is sufficiently well known and you are thus worthy of the attentions of press photographers, then you are a star. You are different from the rest of us, you possess glamour (which used to mean the same thing as grammar: note that you will find no writers here), you belong to a pantheon, you are a myth.

Stardom is regarded as a desirable state, and one wonders why. It is easy enough to understand why a man or woman should wish to produce good work and then retire modestly from that work, leaving it to be praised as an enhancer of life. The great Murray, who slaved away at making the Oxford English Dictionary, deprecated the stardom that was wished upon him. Forget my name, he pleaded, forget my personality, try to pretend that I never existed: the O.E.D. is all that matters. He was right, of course: his work will outlive

the Rolling Stones. But a lexicographer, even a poet, is one who divests himself of personality in order to create something greater than personality. Oscar Wilde, star of sodomy, pointed out shrewdly that minor poets behave like stars while major poets appear to be nonentities. The major poet throws all of himself into his work; the personality that remains is fulfilled, sleepy, totally unglamorous. If Shakespeare were alive today he would never reach the undressed pantheon of this volume. But the minor poet is full of the poetry he cannot write: it flashes off him in flamboyant gestures, drunkenness, spouting Sophocles in Piccadilly Circus; he becomes a star out of his own frustration. There have been only two star writers in the history of Western literature – Lord Byron and Ernest Hemingway. The more fame they attained the worse they wrote. Soviet Russia occasionally unleashes on the West a terrible poetaster named Yevtushenko, a genuine star. He is a frightful warning to all poets who wish to be adulated like movie stars. To produce good creative work you have to forgo stardom.

Unless, of course, you create out of your physical personality, which Chaplin did. Most stars use their physical personalities to interpret what others create: stars are usually what may be termed secondary artists; Chaplin was the great exception. I mean that behind Callas stood Verdi and Puccini; behind Sinatra stand Gershwin and Harold Arlen. Behind every movie star stand a host of primary creators, beginning with the scenarist and ending with God, who invented human bodies. The physical personality we adulate, on-screen and, usually mistakenly, off, is bound up in the creation of faceless men and women, but it is these faceless who make that physical personality glamorous. Where would Dietrich have been without the genius of lighting who remade her beauty from beneath, without Sternberg who showed her how to deploy that beauty in movement, and – behind everybody – those writers whom Goldwyn called 'shmucks with Remingtons'? Dietrich, whom we see in this book very old and very ordinary, will serve as an example of both the tragedy and miracle of stardom. The Dietrich we worship belongs to an eternal now – a past preserved on film that has become timeless. The Dietrich we see at a Paris airport is the shell of that glamour: all that remains of her is a name. Is a burnt-out star still a star? There is a peculiar combination of mercy and justice in the early deaths that overtook Valentino, James Dean and Marilyn Monroe. Gods and goddesses cannot, by their very nature, grow old.

In this book you will see what time has done to glamour, but you will see also what the camera, without benefit of time, can do to it. An unbecoming posture of the body, a grotesque movement of the mouth, a graceless gesture can be caught by the photographer and cancel out a whole legend. This, we assume, is what these divine creatures are really like, but that is only because we believe the camera cannot lie. A lie is a human action, and cameras, though activated by human hands, are not human. It all depends on what you mean by the truth. Pontius Pilate, who is given the best lines in the New Testament, asked what truth was but would not stay for an answer. What we do know about ocular truth, meaning the true nature of what our eyes observe, is that it has nothing to do with frozen split seconds. Life is movement; it is curve and duration, not the arrested point. Photography as art is, like painting, concerned with suggesting movement; when it tries to capture a human personality it wishes to give the impression of that personality existing in time, not in the timelessness of the split second. The photographs in this book do not pretend to be art. They are cruel but they are corrective: the images of gracelessness remind us that even myths are mortal.

They also represent small victories in a long war between the powers of deflation and what stars regard as their right to privacy. Whether a star has a right to privacy is a big question we must now attempt to tackle. Greta Garbo claimed that right more than any of her fellow-stars, and there was logic behind her claim. It was argued that she had a duty to her public, that of being available to be seen in the flesh occasionally. But, she answered, what has the flesh to do with the flat screen image? It is that image that my fans, presumably, adore, and they are welcome to that image. They pay to see it, and I respect that covenant. But the public has no further rights. To reinforce her argument she drove a great wedge between her two-dimensional image and her three-dimensional reality. She slouched through the rain in flat heels and a raincoat, the very perfection of unglamour. She had no *obiter dicta* to be treasured. When she was forced into meeting people she was often downright rude. If you wanted the commodity called Garbo (which was not the same as the living creature called Greta Gustafsson), you could unroll her from a tin box. No other star has been so unaccommodating, but the refusal to carry the myth over into real life never did her career any harm.

Other stars want the best of both worlds. They want to be loved on the screen, and they want to be loved at

airports and charity galas. They wish to be off-screen gods and goddesses, but, in the manner of deities, they insist on dictating the terms of their worship. They reserve the right to wave off the encroaching photographer and, at times, smash his apparatus. They must be seen only at their best – unpunched by enemies, unhangovered, unstoned. They demand from real life what is imposed on them on the screen – the essentially artificial postures of glamour. Such stars deserve the worst that sly photographers, darting through the chinks in their barricades, can dole out. If they want to be loved in real life they must accept the terms that the rest of us have to suffer – ugliness exposed to the air – but not all of them are willing to.

The difference between public and private life rests on the premise that there are some human functions intended to be performed behind locked or at least closed doors. In our age a great many behavioural taboos have been broken, but most of us would accept that one ought to weep, give birth, defecate, micturate, vomit and make love in private. There is no photographer in the world who would wish to catch one of us non-stars in such animal nakedness, but the rules change for the great and glamorous. A picture showing Romy Schneider going into, emerging from, or best of all *in* a public toilet would be very valuable, but it has not yet been taken. It is enough to catch her being privately naked. But the war goes on, and the photographic craft may yet show Roman Polanski in his amorous bed, not just (as in this book) earnestly chatting up juveniles.

What will strike the porer over these pictures most is the ugliness of the beautiful and the shortness of the great. I have met various stars in my time, and they have all, with few exceptions, been stubbier than I expected. On the film set a lot can be done to add height with what is known as a pancake, but this is a device intended not for superhumanizing height, only for bringing it up to the range of normality. There is a theory that the ambition which results, with luck and fanatical hard work, in stardom is an urge which compensates for lack of inches, or centimetres. The ugliness is a different matter, for few star-quality actors and actresses start off their careers without the recommendation of beauty. True, age has done its worst with some of the subjects here, and camera cunning has caught, as it were, the occasional leer which comes even to the successful beautiful and is the ugliest thing in the world, denoting as it does total self-satisfaction. But, even at the best, these people seem very ordinary – Elton John

pathetically plebeian in his vulgar get-up, Tom Jones smirking indecently as if after his sixteenth pint. And is that chunk of sullen flesh on her private pier really Brigitte Bardot?

It says much for the photographer's skill that Sophia Loren, the most beautiful woman in the world, has turned here into a spotty harridan with a most unbecoming afro. In real life Sophia Loren is tall, smooth-skinned, elegant and gifted with a flawless bone-structure. I have sat with her for as long as three hours and looked with a kind of desperation for flaws, but flaws there are none. Yet her picture here is a flawless study in flawedness. It says much for Orson Welles's suggestive power that he has imposed on his likeness a suggestion of infantility: he said once that he had an unfulfilled ambition to play a child prodigy pianist. It says much for Richard Burton's fundamental insouciance that he looks, in all his photographs, as he regularly looks, on-screen and off. Liz Taylor doesn't give a damn either. She may even complain that the photographs have fined down her fat, an attribute which, denoting happiness as opposed to self-satisfaction, she appears to cherish. As for Alfred Hitchcock, his legendary fatness has swollen to the mythical grotesqueness of a screen logo, and we are always surprised to see how (comparatively) unfat he is. I once travelled with him in the same elevator in Claridge's, and there was room for at least four others, excluding the liftman. Dustin Hoffman, who is very short, takes the wind out of the sails of the deflators by making himself look even shorter, with his very tall wife there to help. In fact, a few of these stars come out of the ordeal by click rather well.

A sad thing about this compilation is the absolute certainty that, in perhaps less than thirty years, those who discover it on a second-hand bookstall will wonder who these people were and what all the fuss was about. But for us leafing through it now, or poring on certain pages with appalled fascination, there is already implicit in it the lesson of the vanity of a particular kind of fame. Callas dies but Verdi lives, and there will always be other singers to sing him. All that Onassis did was to make money. Rostropovich scrapes horsehair on sheepgut, but Bach and Britten had to give him the notes. There will be new violoncellist virtuosi waiting to take over when he goes. Art lives for ever, but executants are relatively expendable. This book, in bringing them down to the human level, is a kind of visual poem on the theme of expendability. Who is the Duchess of Windsor? An American divorcee who

provoked a constitutional crisis. Who is the Queen Mother? The mother of the Queen. Who is Benedict of Denmark? A personable young woman sitting with a not talentless film star who never lost his charm. Did these people have much to do with the making of the modern world? Very little: they were the decorative icing on a cake that hurt both our teeth and our stomachs.

They already seem like ghosts, but ghosts have the power to haunt. I write these words away from the pictures, but many of them are stuck in my brain like *croûtons* in pâté. The face of Aristotle Onassis seared and trenched with the agony of being rich. Jackie Onassis looking lost. The great Callas looking as shabby as an underpaid under-librarian. Gloria Swanson parodying, with the help of old age, her former beauty. I wish to cry: no, let me keep my illusions; forbid these embodiments of glamour a private life which *paparazzi* can sneak in on. I want Callas as Medea and Jackie not to be the Medea she became after Dallas. But our photographers are tough and wish to teach sharp lessons. They want to remind us that fame and wealth do not transfigure, they debase, and that it's all symbolized in Barbara Hutton being carried like a doll to a taxi.

Despite the levelling policies of the socialist philosophy, a world poll, even a third world poll, on the future of the famous and rich would judge that the inordinate rewards should continue. We want certain people to be famous and rich, with or without talent, so that we can be the better satisfied with our own indigent obscurity. No rise without a fall, and the gods demand punishments not from the mediocre but from the ambitious. One of the punishments is a book like this, with its brilliant craft of exposure. It lays on the whips. Give your sadism full play: relish what lies within here. The extraordinary are revealed as terribly ordinary, and there is no diviner punishment than that.

Anthony Burgess

Monaco, 1980

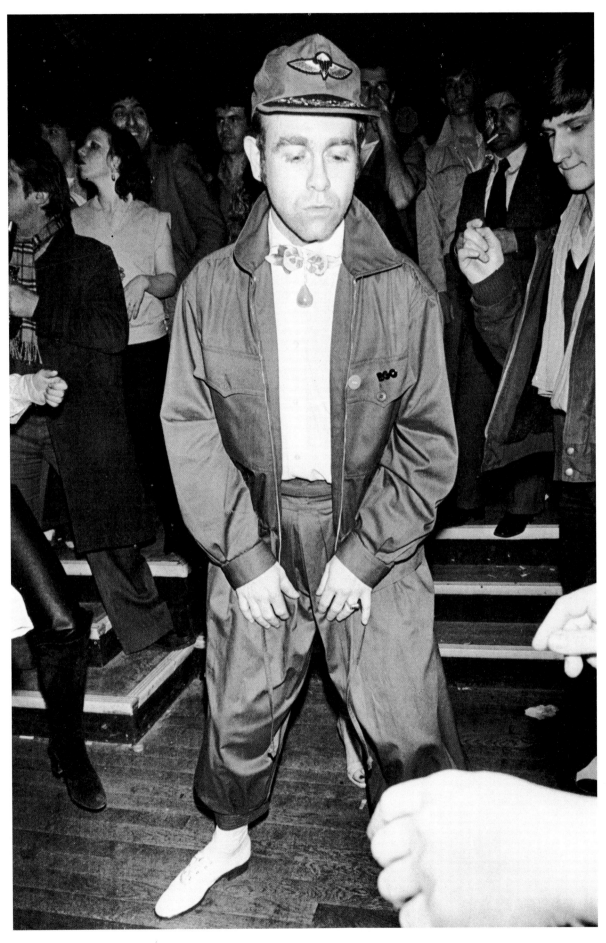

Elton John at 'The Palace' nightclub, Paris (1978)

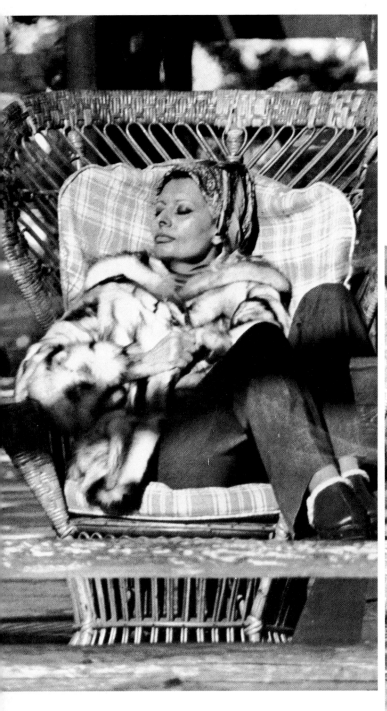

January sunbathing in Megève, Sophia Loren (1978)

At a Christian Dior fashion show two months later, Miss Loren appeared with a new hairstyle – never to be seen since

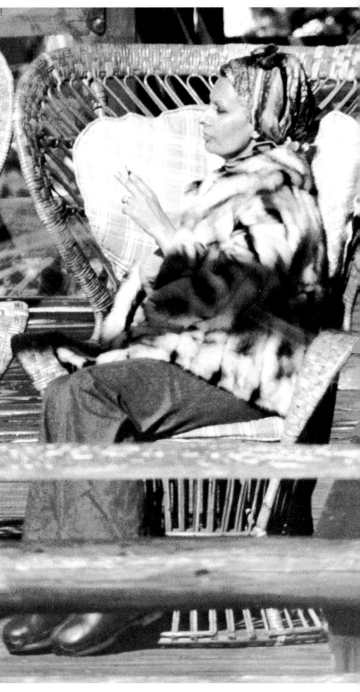

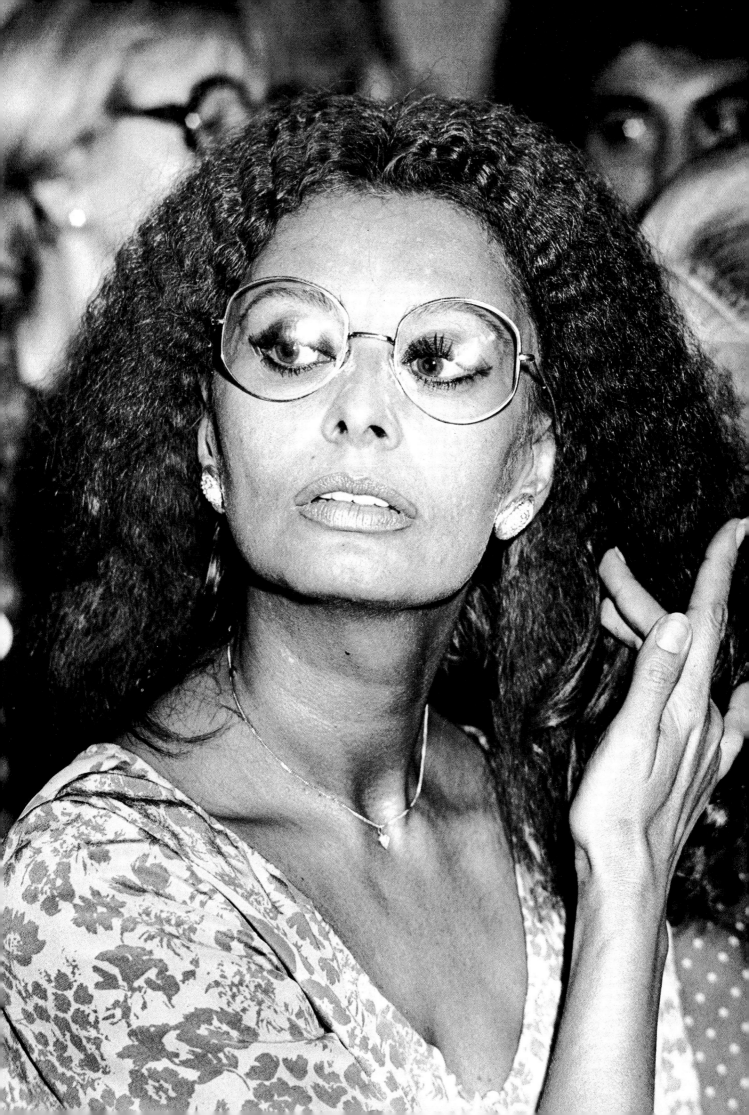

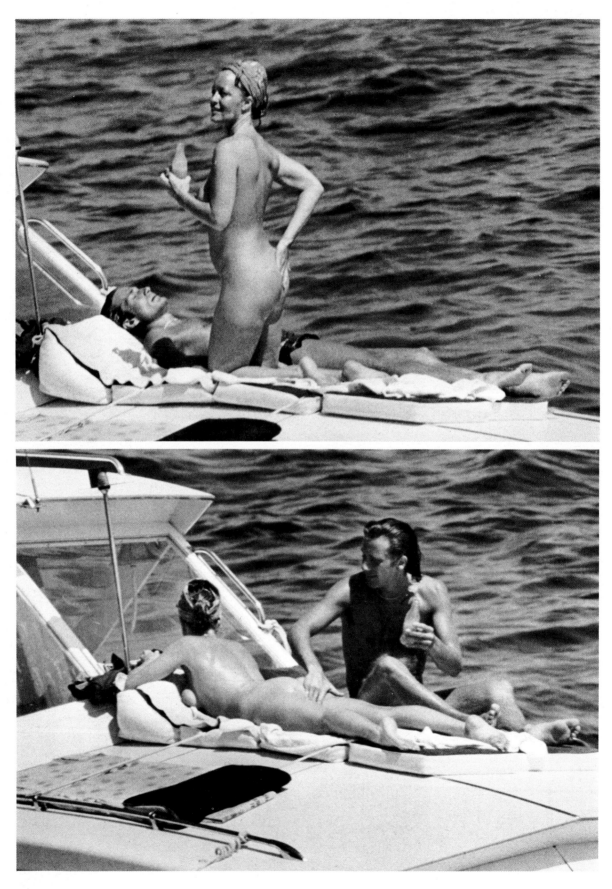

Romy Schneider and her husband Daniel Biasini on their boat, Cap Camarat (1977)

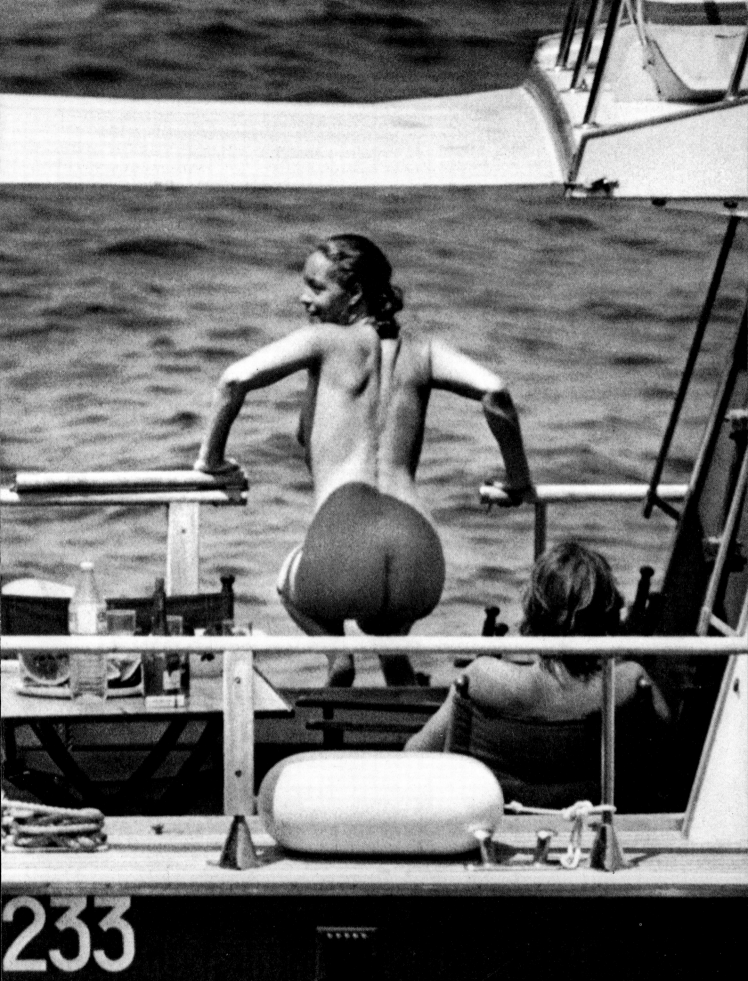

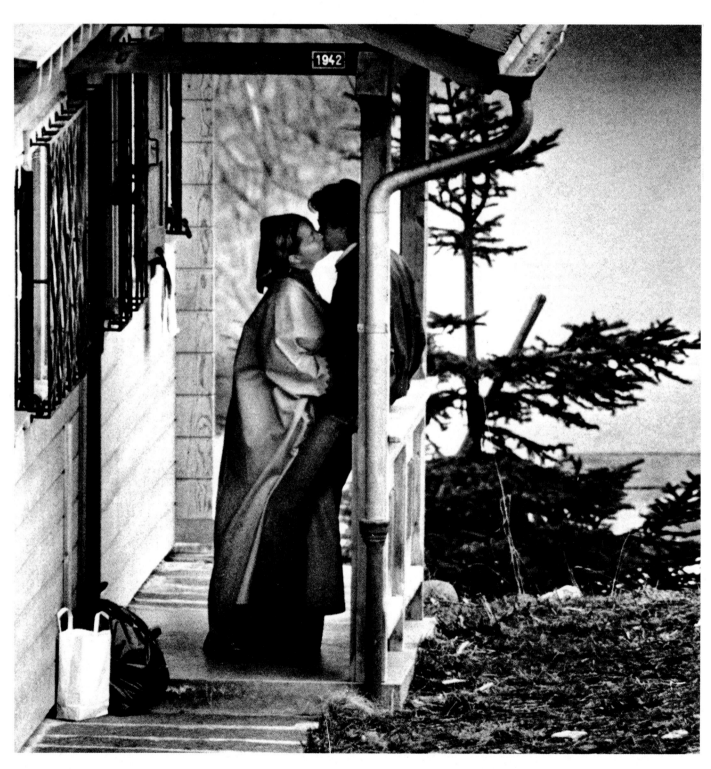

Expectant mother Romy Schneider and Daniel
Biasini at Les Diablerets, Switzerland (1978)

Lord Snowdon returns to his mother's London
home after the Royal separation (1977)

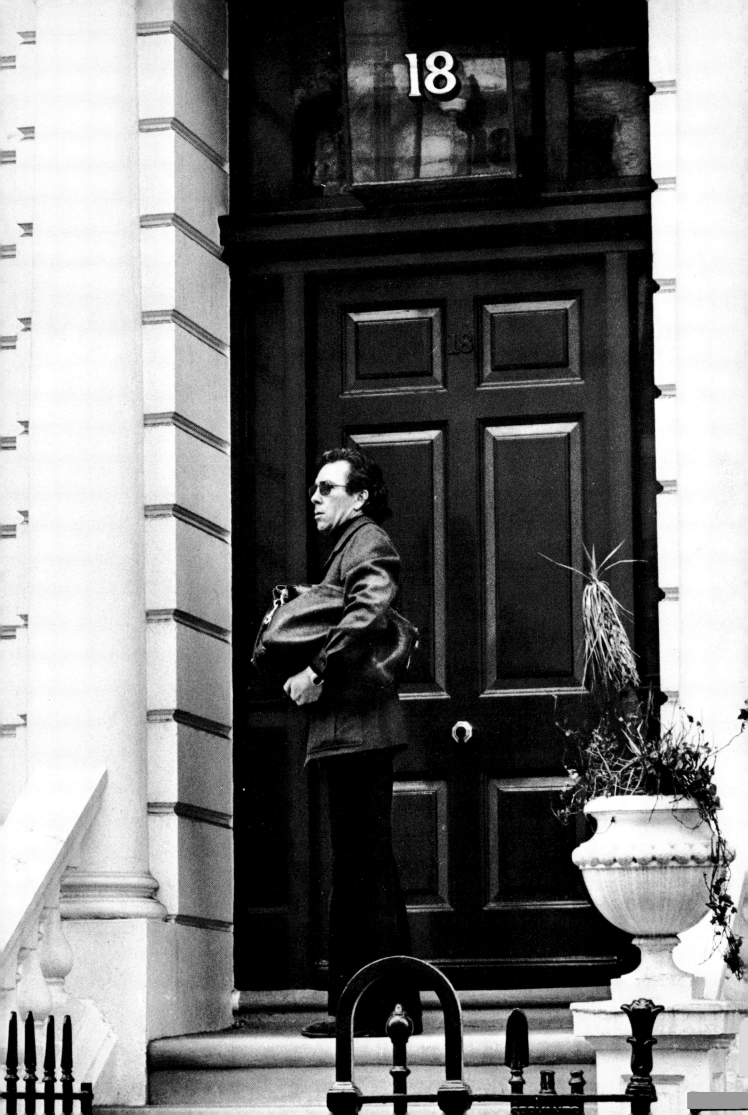

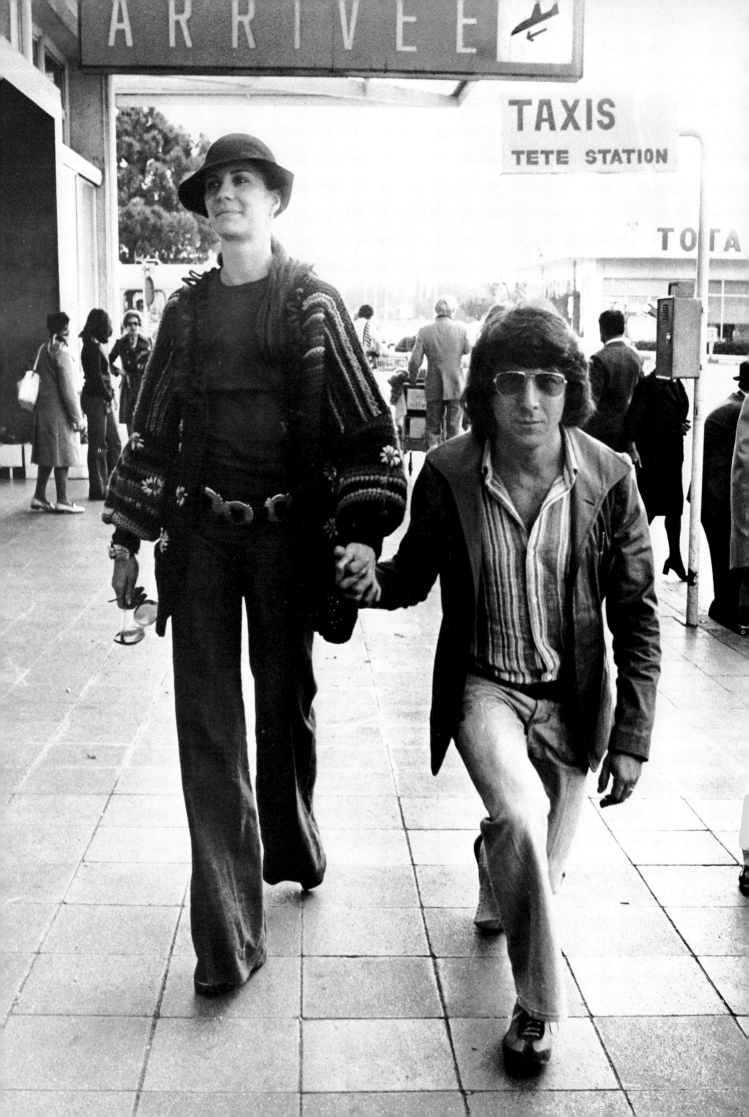

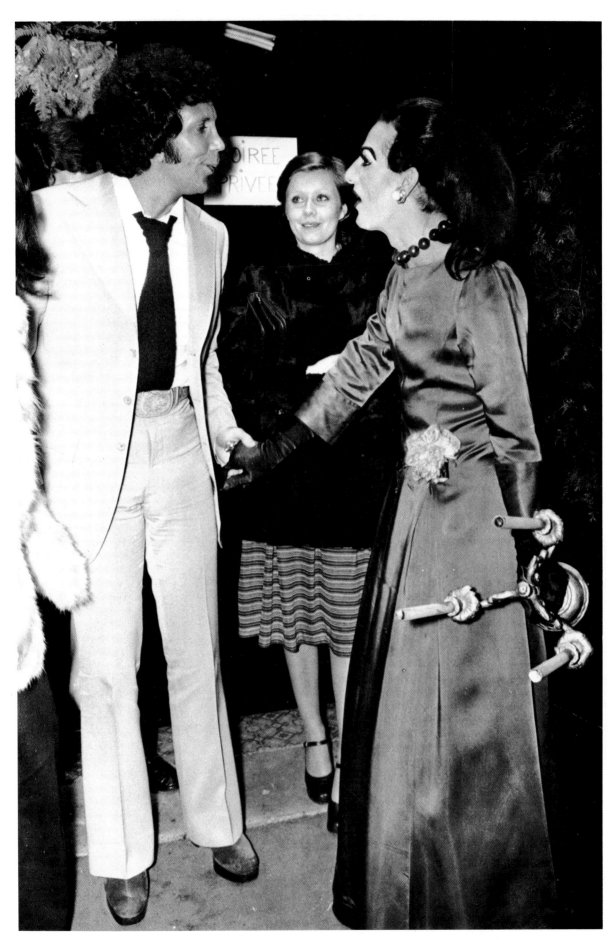

Tom Jones with transvestite (as Maria Callas) after
the drag show at 'Michou's' in Paris (1976)

The arrival at Nice Airport of Dustin Hoffman and
his wife (in 1977) for the Cannes Film Festival

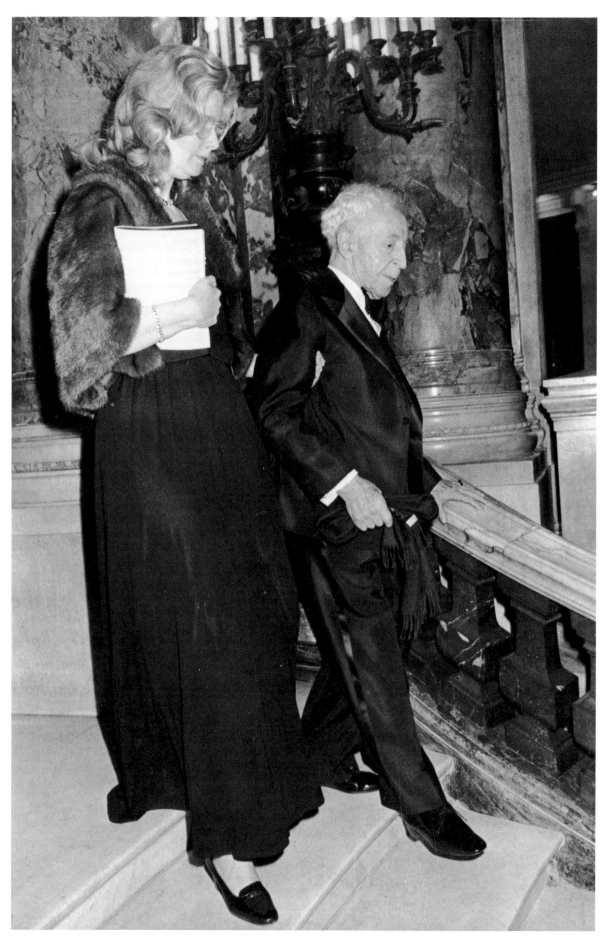

Arthur Rubinstein with his secretary attending the
opera in Paris (1978)

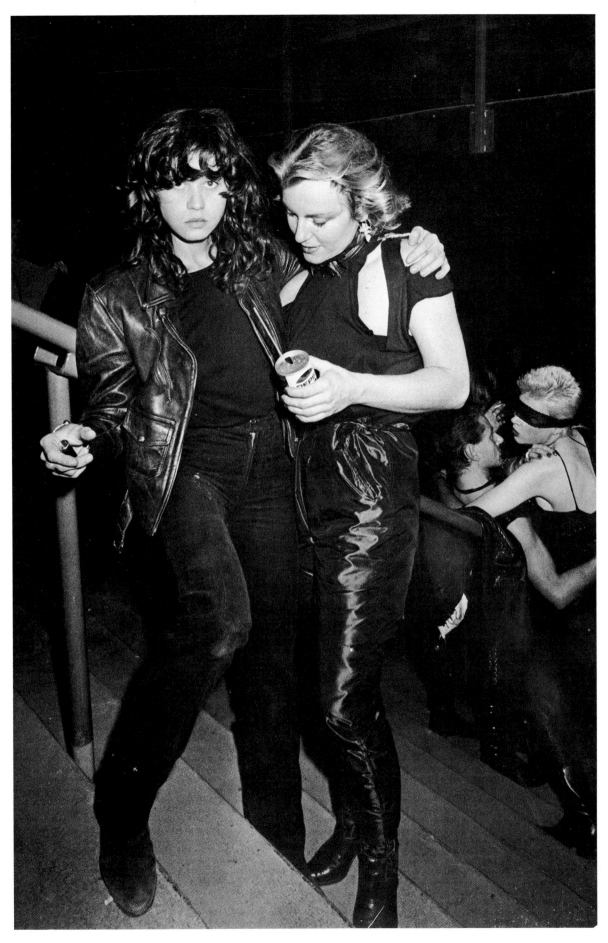

At 'La Main Bleue', Maria Schneider and a friend
(1978)

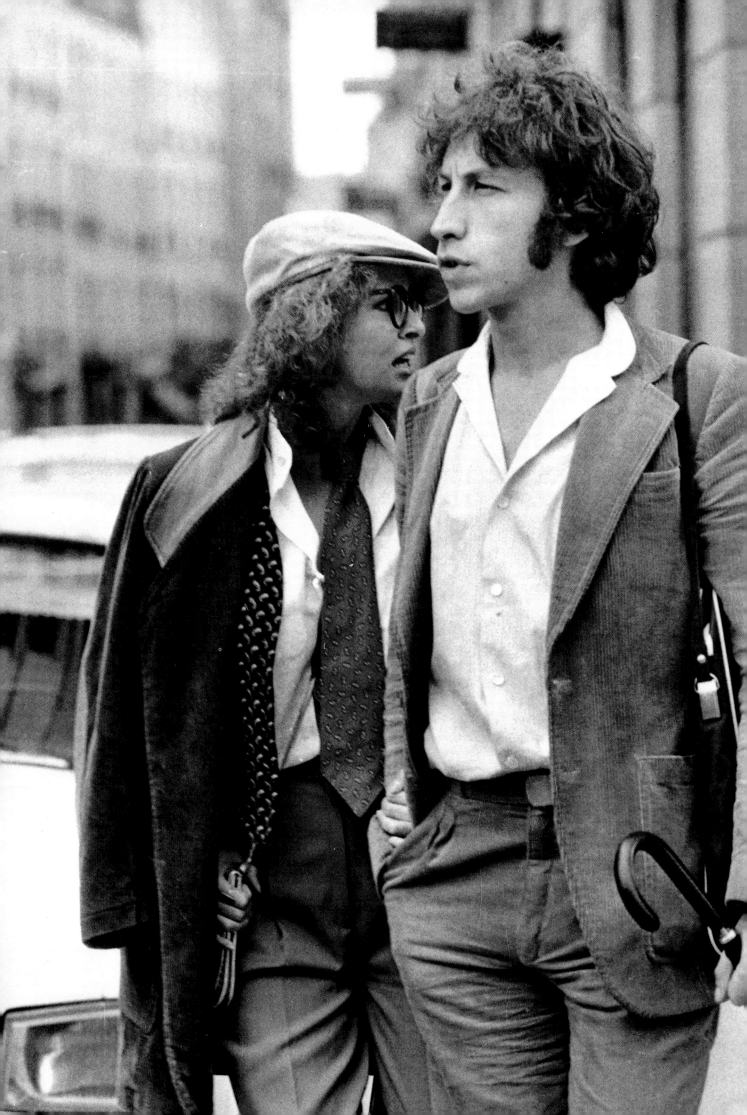

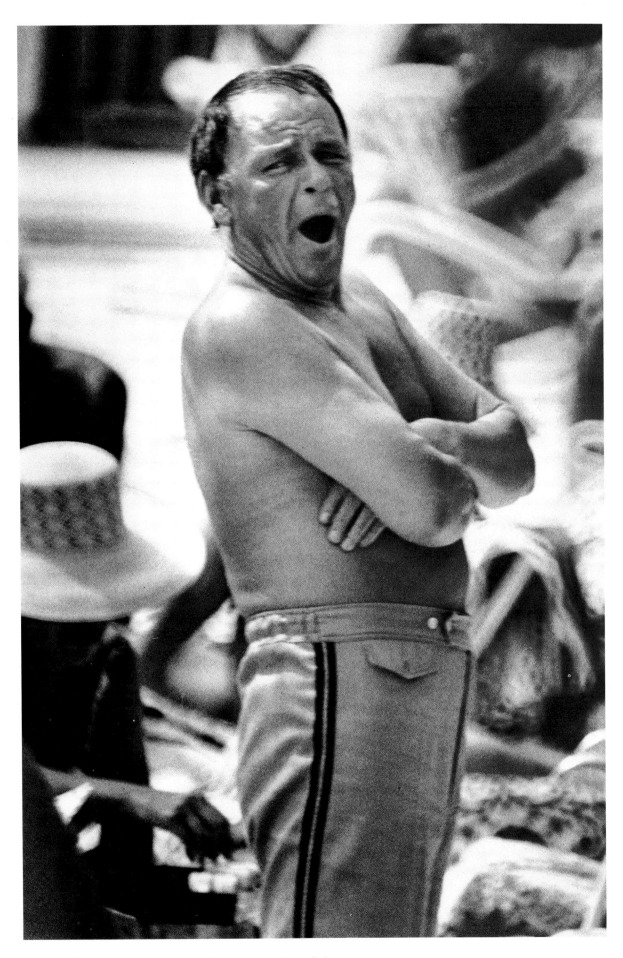

Frank Sinatra ready for anything at Palm Beach in
Monaco (1975)

Raquel Welch with her boyfriend André Weinfeld
in Paris (1977)

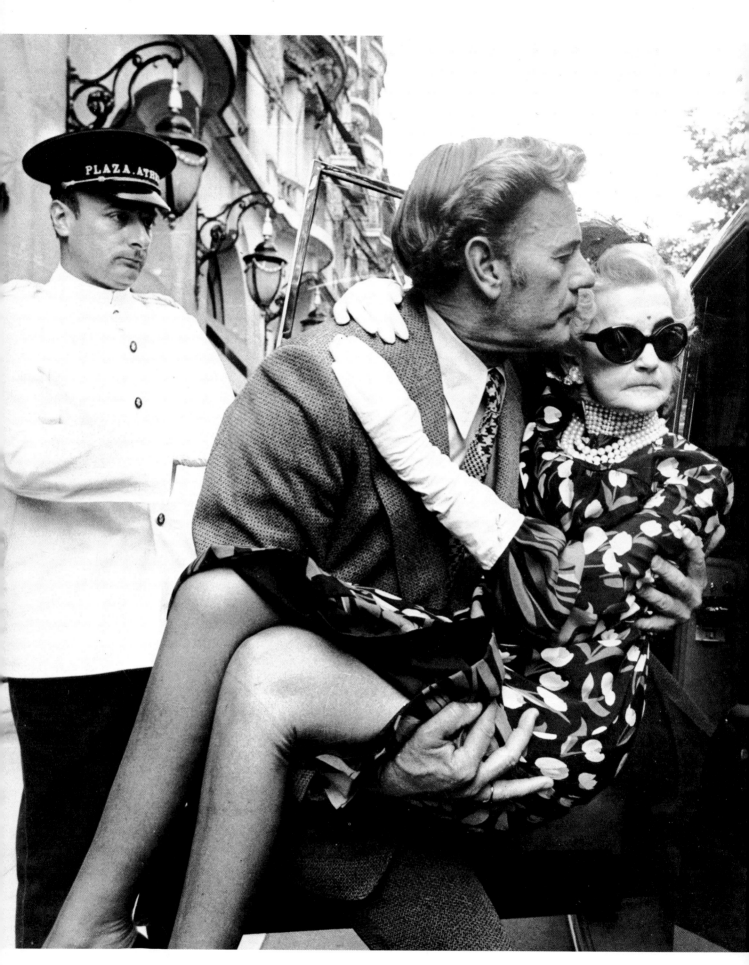

Barbara Hutton leaves the Plaza Athenée, Paris, in the arms of her chauffeur-secretary, 'the only man who refused to marry her' (1976)

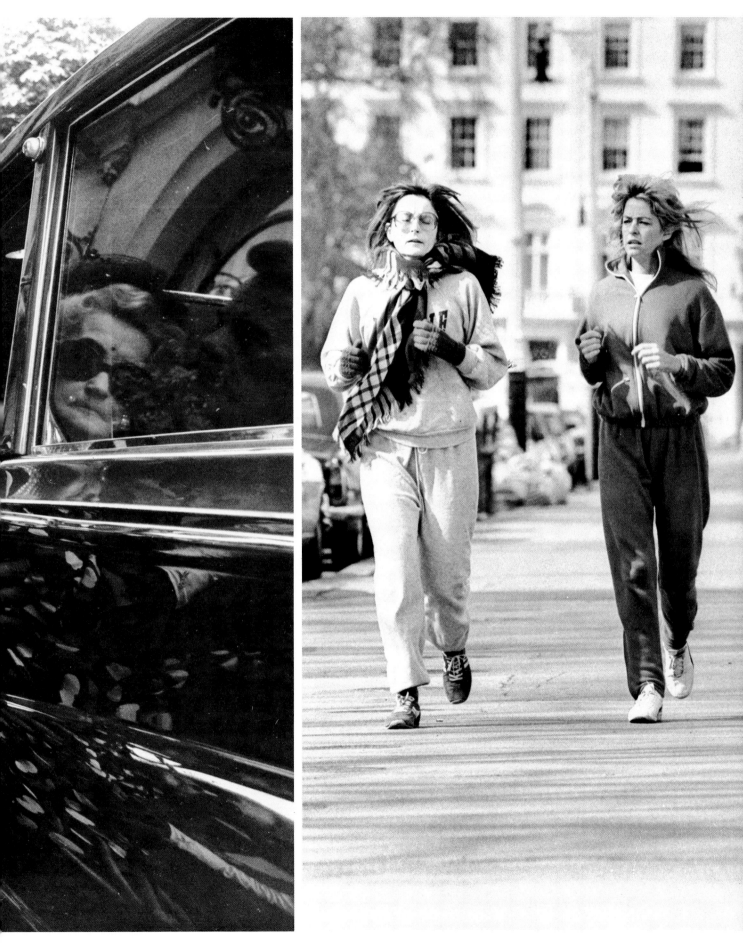

Farrah Fawcett on her morning jog round Eaton
Square, accompanied by a friend (1979)

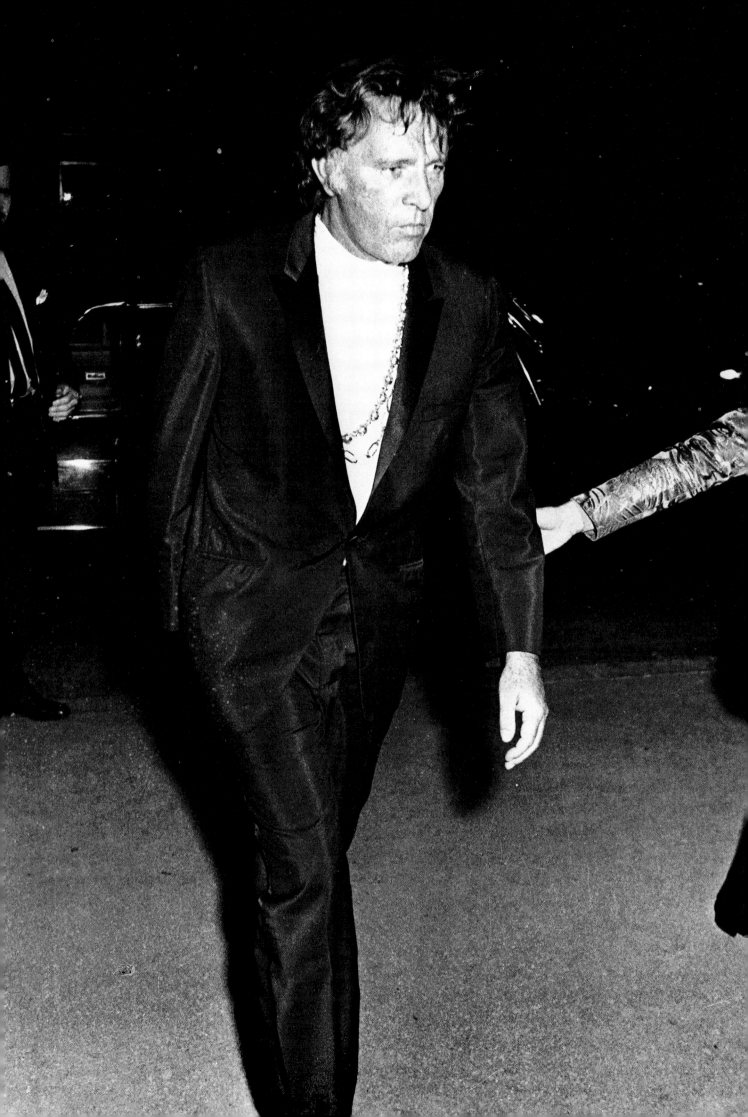

Richard Burton leaving a party given by the
Vicomtesse de Ribes, and arriving at the Plaza
Athenée shortly thereafter (1967)

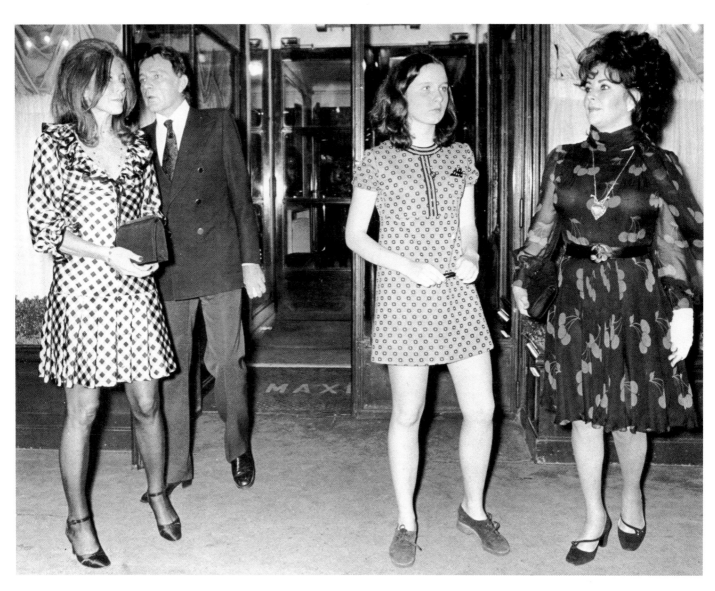

The Burtons dine at 'Maxim's' with their adopted
child Maria and Bettina Grazziani (1973)

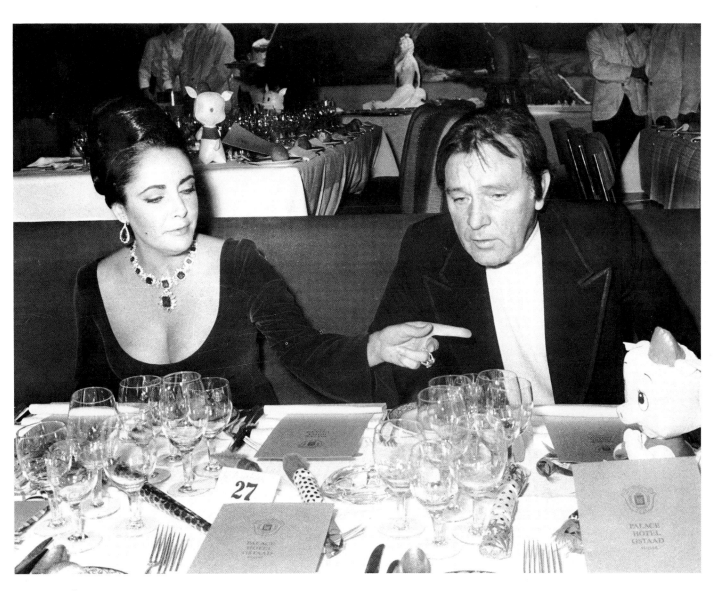

À deux at the Palace Hotel, Gstaad (1976)

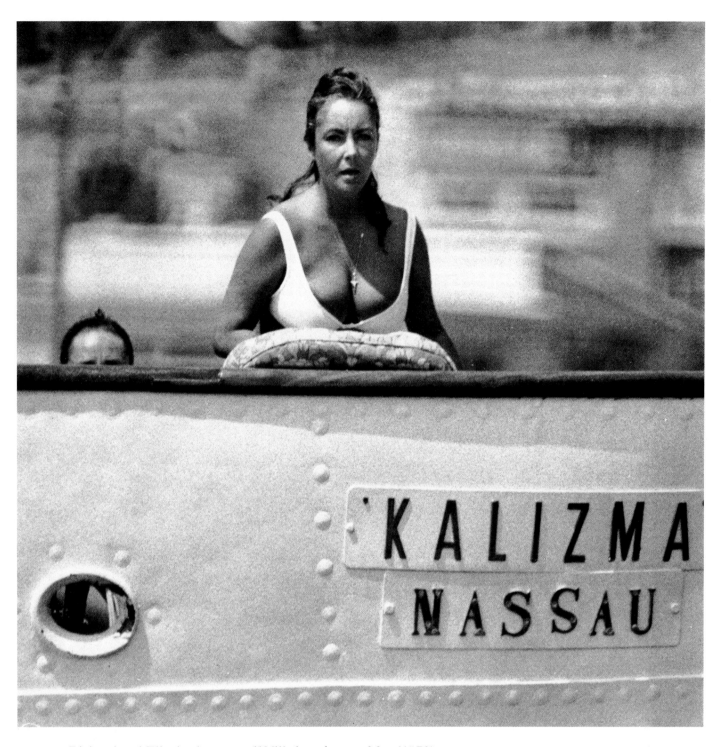

Richard and Elizabeth at sea off Villefranche-sur-Mer (1973)

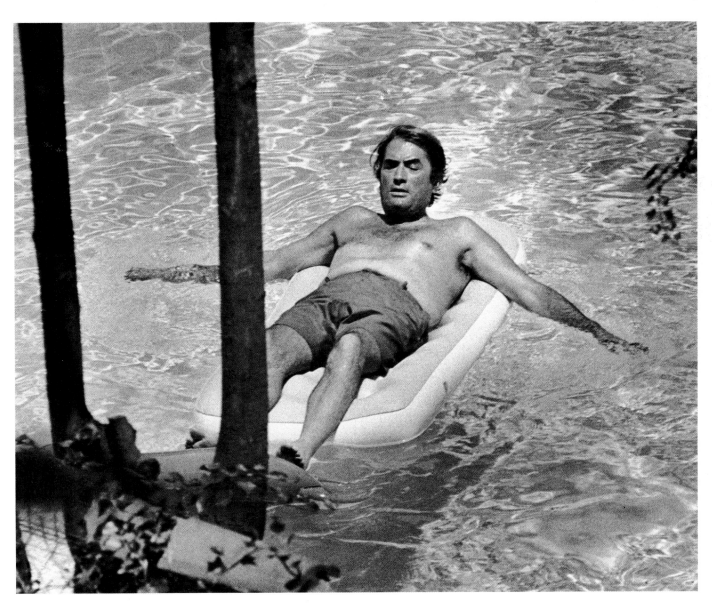

Gregory Peck lying low at his villa in St Jean Cap Ferrat (1975)

Giscard d'Estaing at the beach, St Jean Cap Ferrat
(1975)

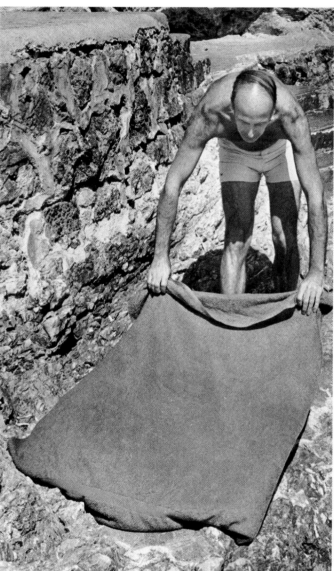

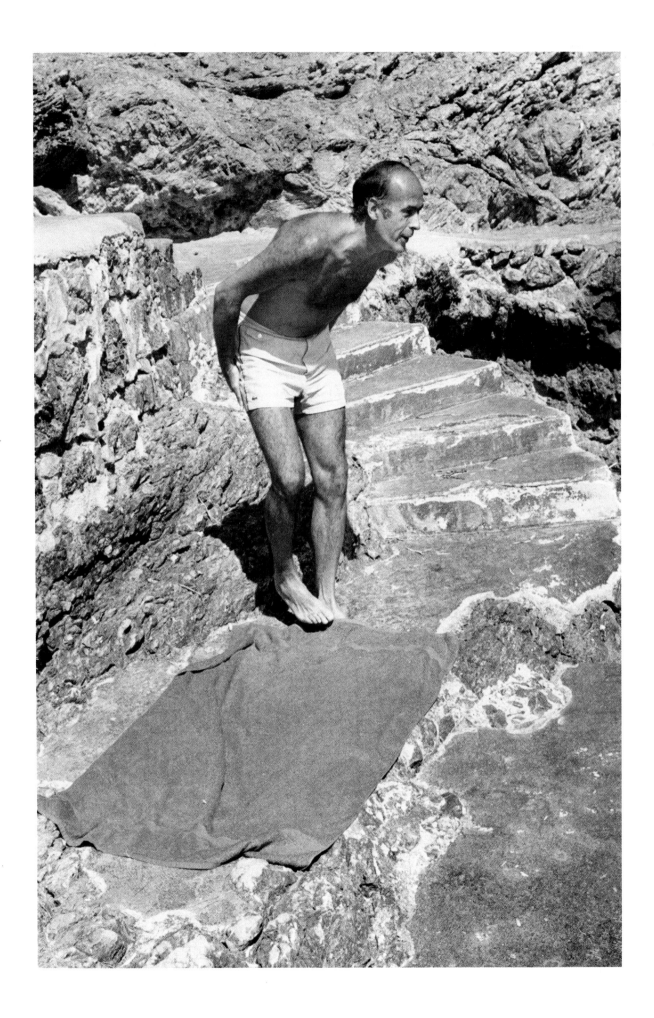

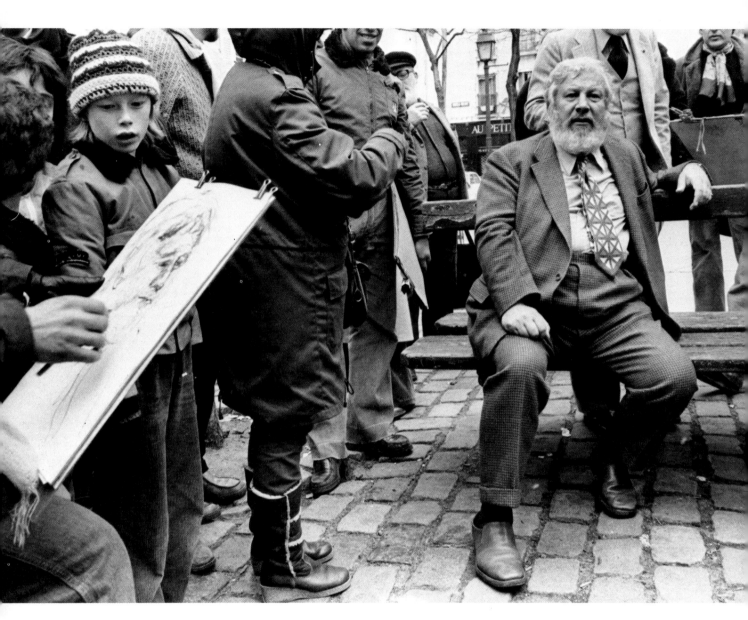

Peter Ustinov sits, Place du Tertre, Paris (1976)

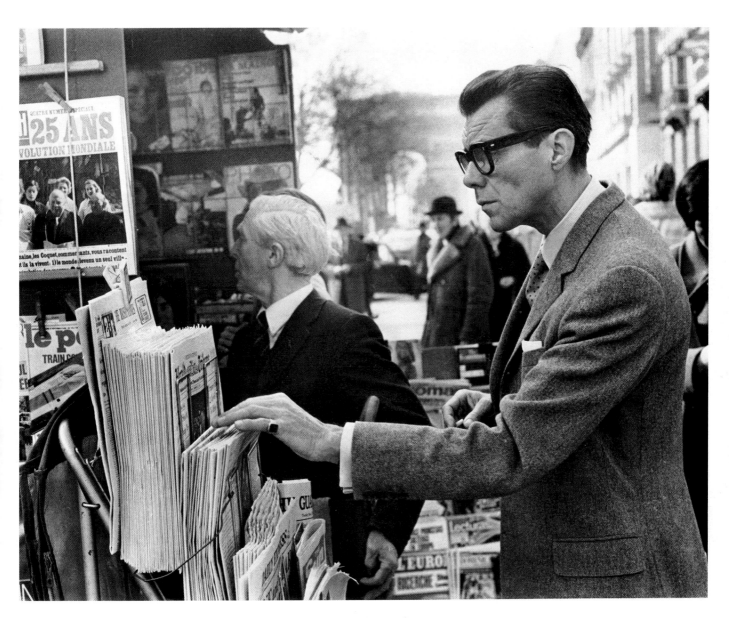

Selecting his newspaper on Avenue Montaigne, Dirk Bogarde (1975)

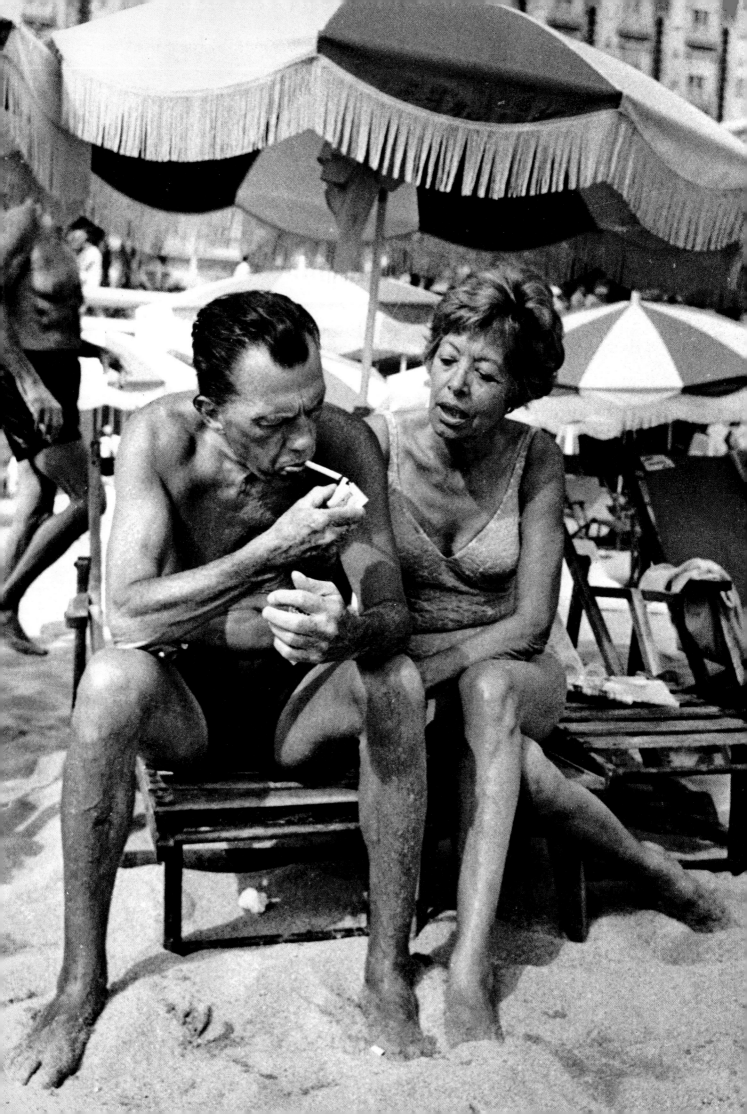

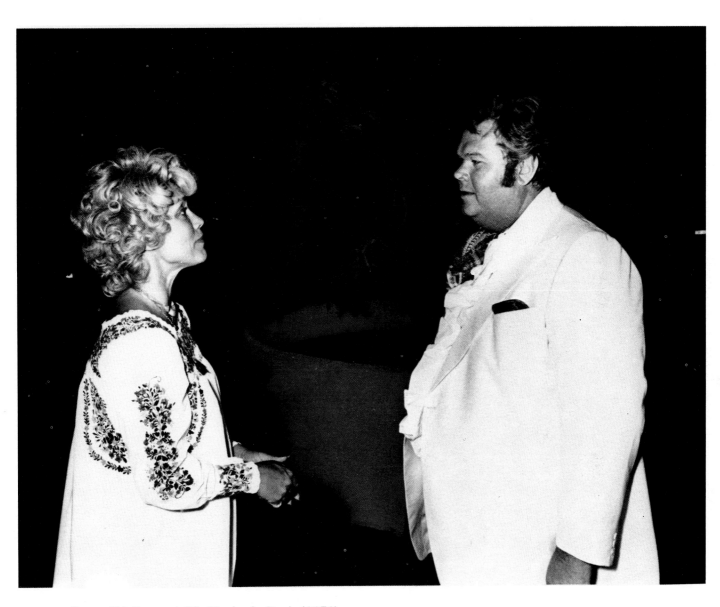

Orson Welles and Gia Kodar in Paris (1979)

Mr and Mrs Ed Sullivan at Cannes (1974)

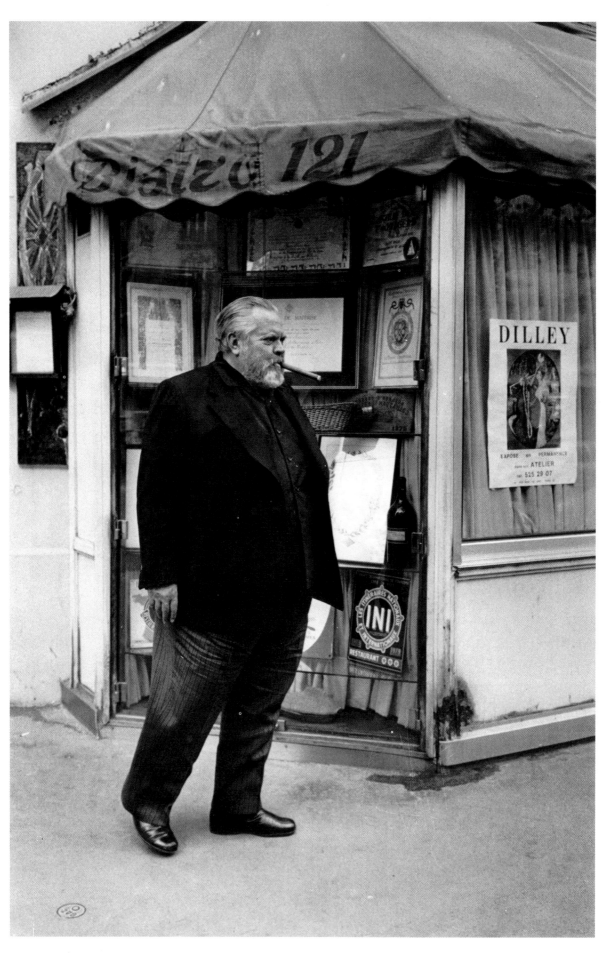

Departing from 'La Mediterannée', Orson Welles
on one of his frequent pilgrimages to the
restaurants of France (1976)

Alfred Hitchcock and his wife
on a film set in Paris (1972)

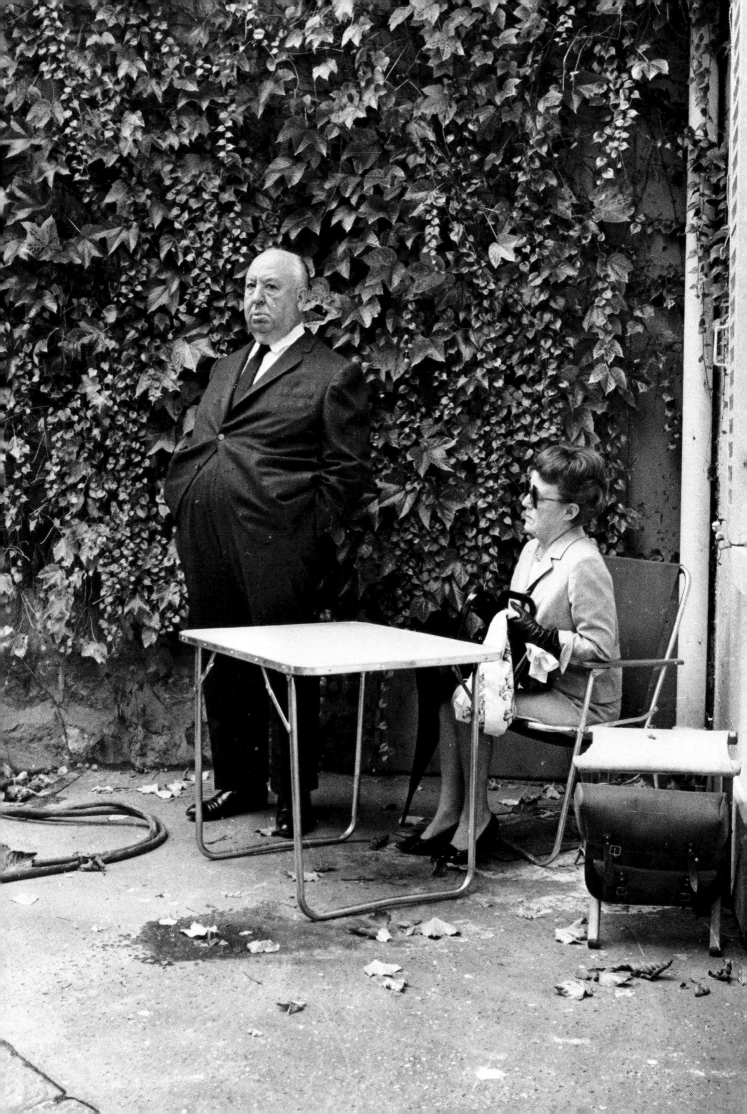

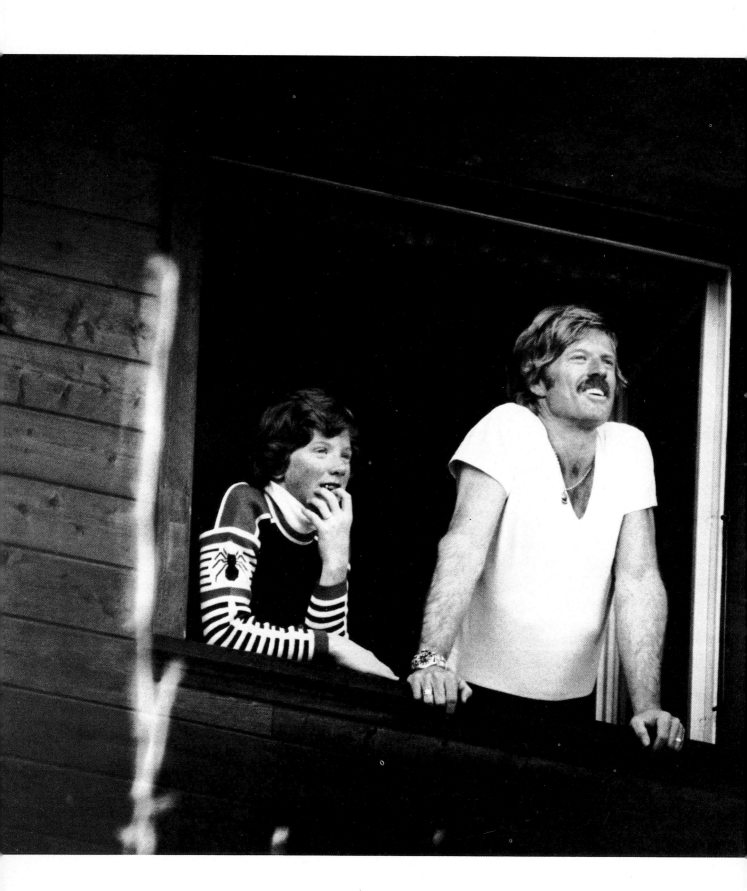

Taking the view from their chalet in Wengen, Switzerland, Robert Redford and son (1977)

Chagall and wife bathe at St Jean Cap Ferrat (1975)

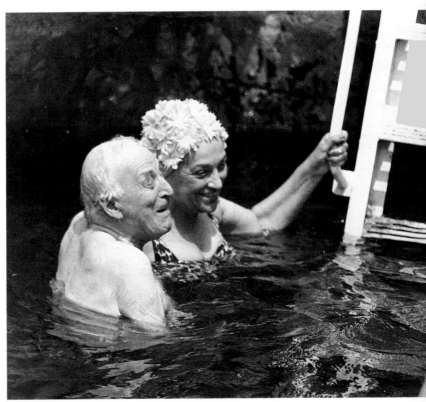

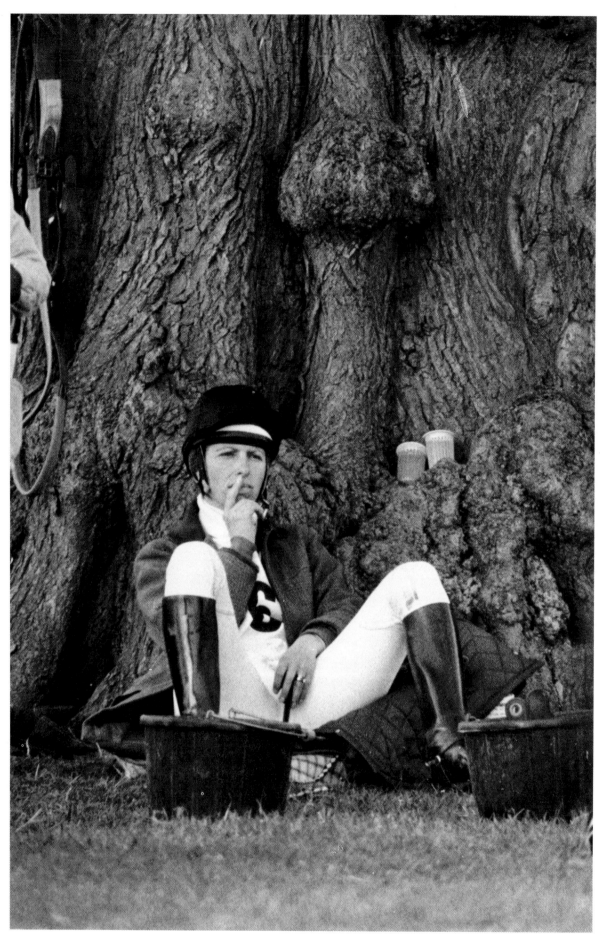

A reflective moment after the Badminton cross-country course (1977)

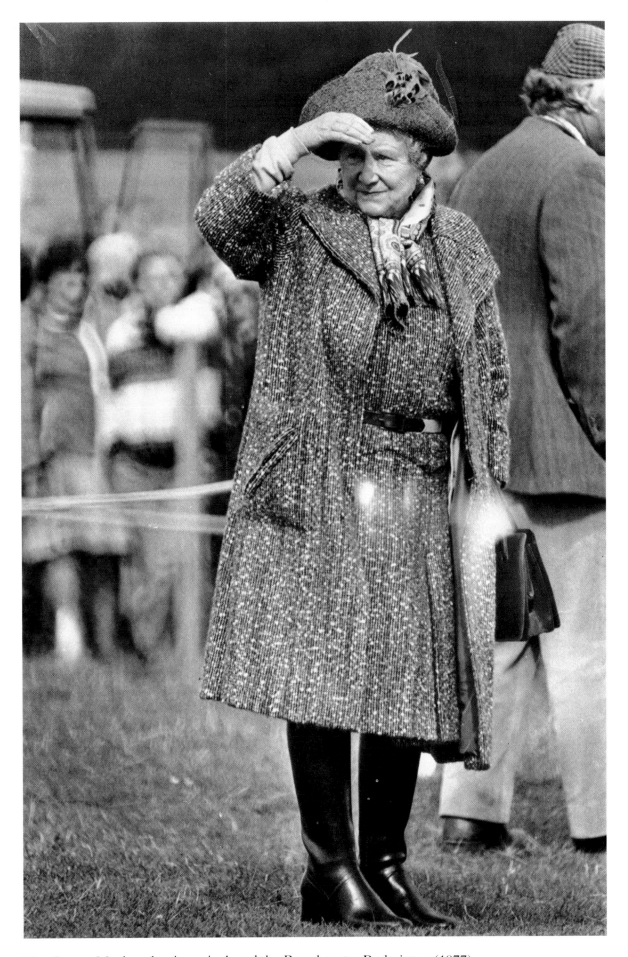

The Queen Mother, having misplaced the Royal party, Badminton (1977)

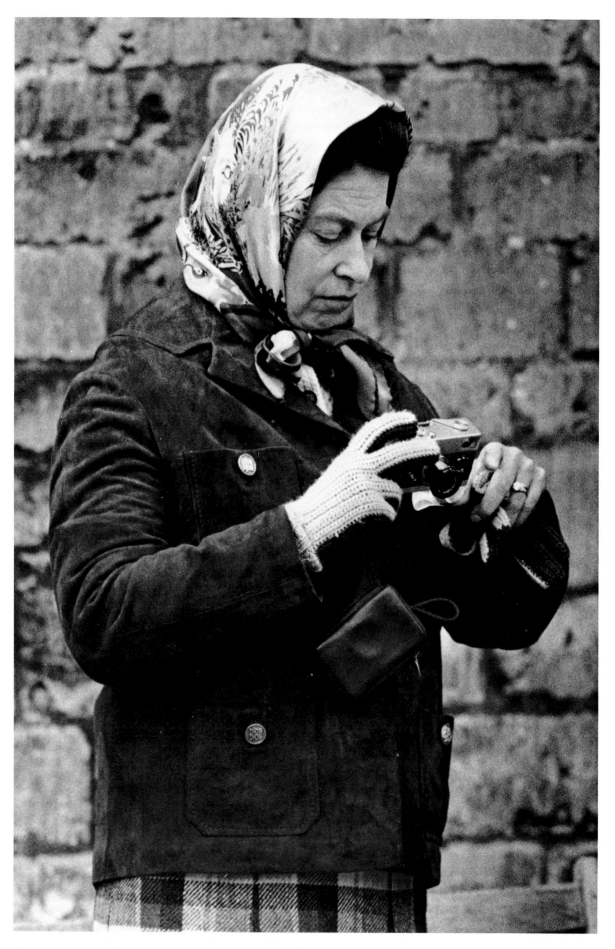

The Queen deliberates over her 35 mm Rollei,
made of gold parts, before the Horse Presentation
(1977)

Prince Philip pauses at the Windsor Horse Trials (1976)

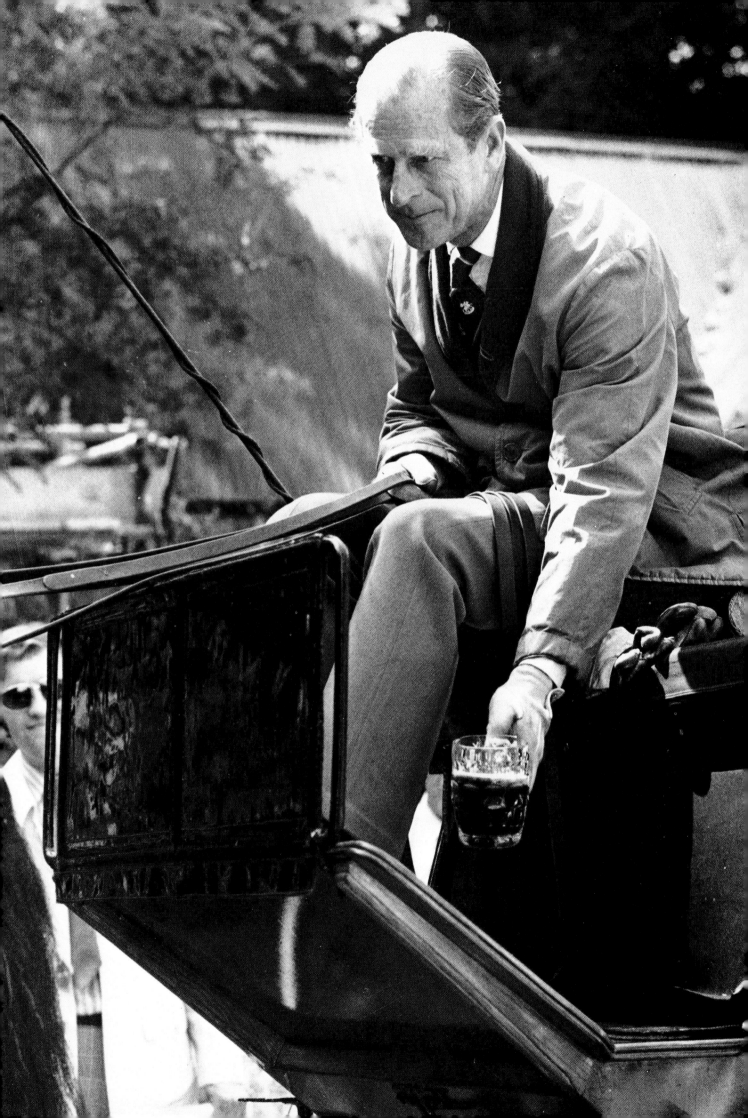

Her Majesty (1977)

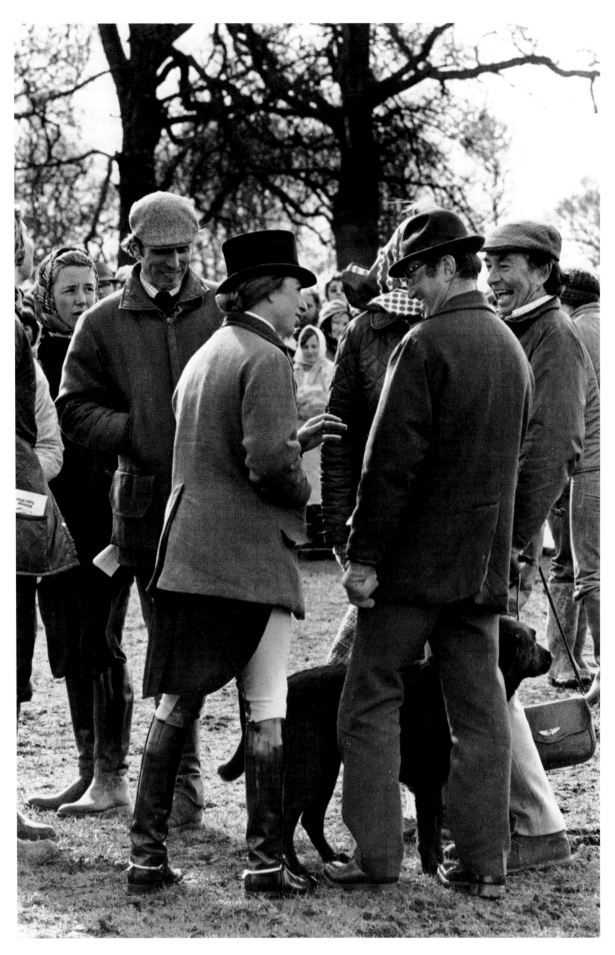

Princess Anne and Mark Phillips between events (1977)

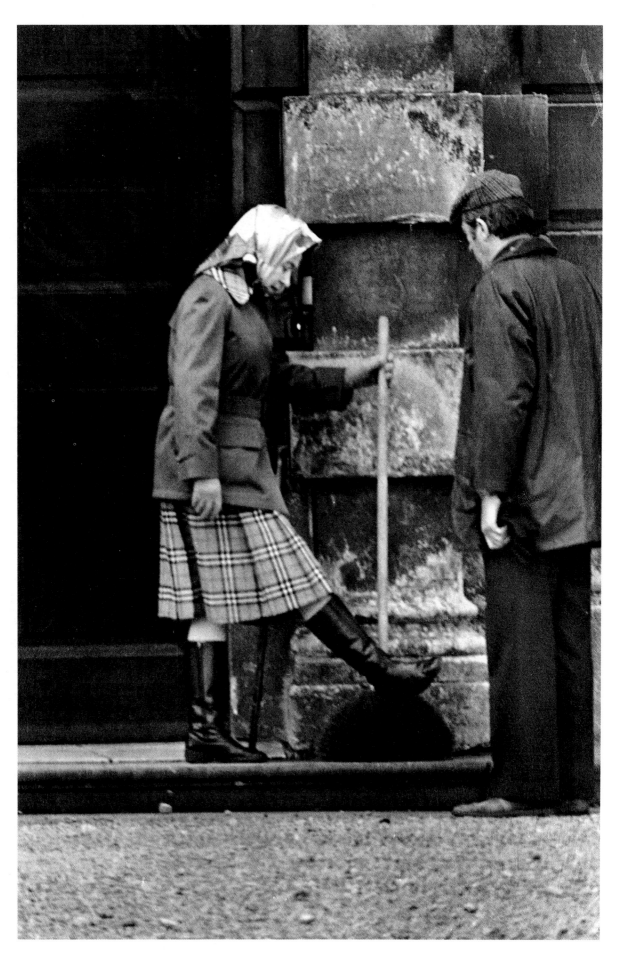

The scraping of the boots, Badminton Mansions (1978)

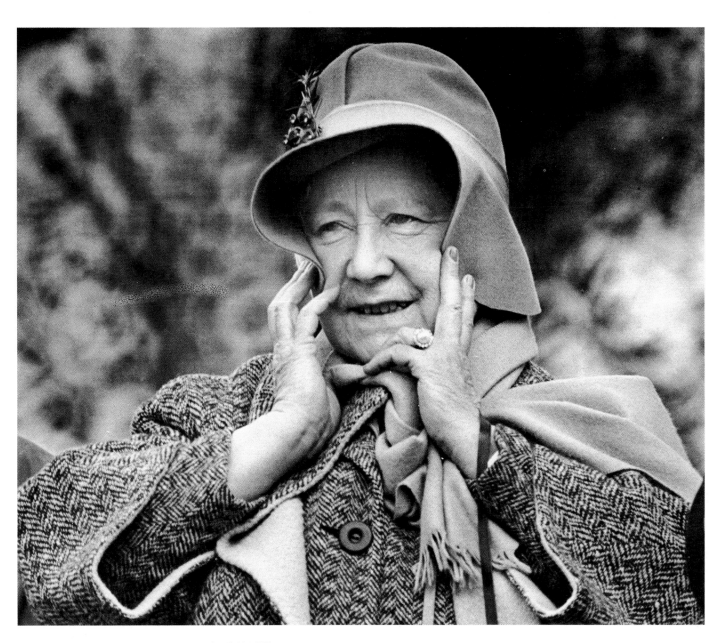

Queen Mother in the wind (1977)

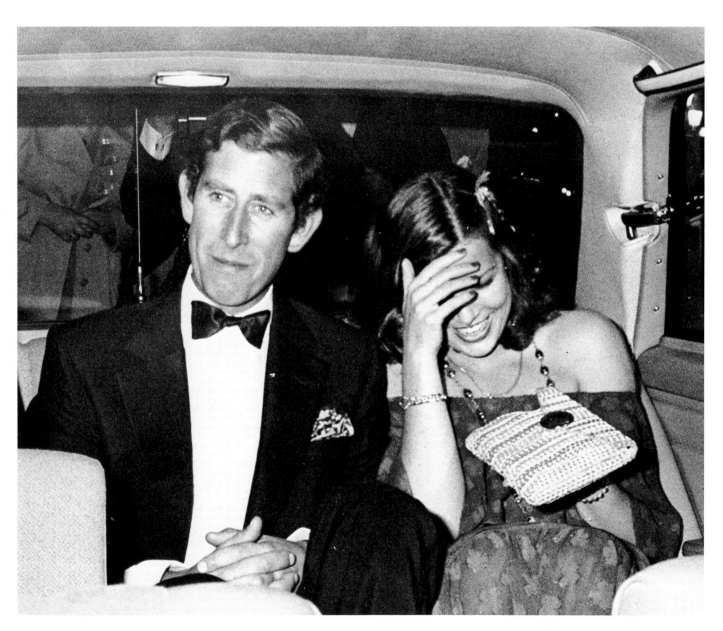

Prince Charles on a three-day visit to Monaco for the coming out of Princess Caroline, here ambushed by press after an official dinner-party at the Hôtel de Paris, Monte Carlo (1977)

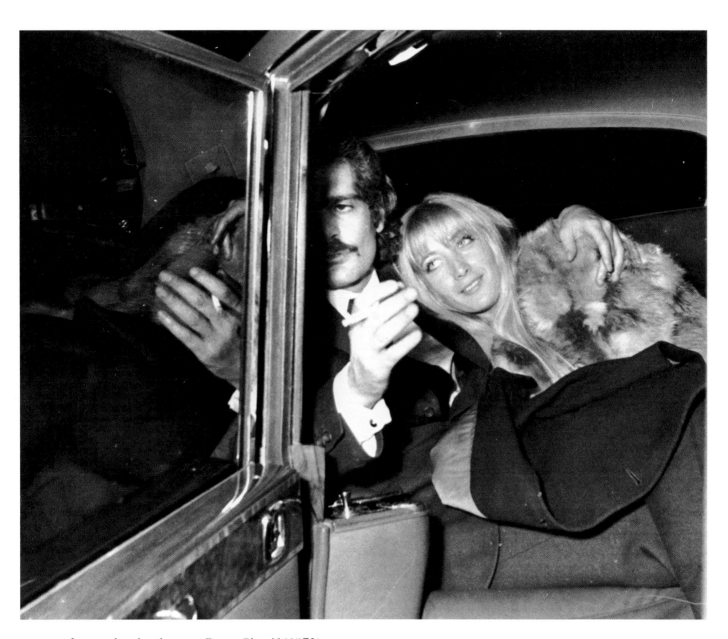

In another back seat, Omar Sharif (1973)

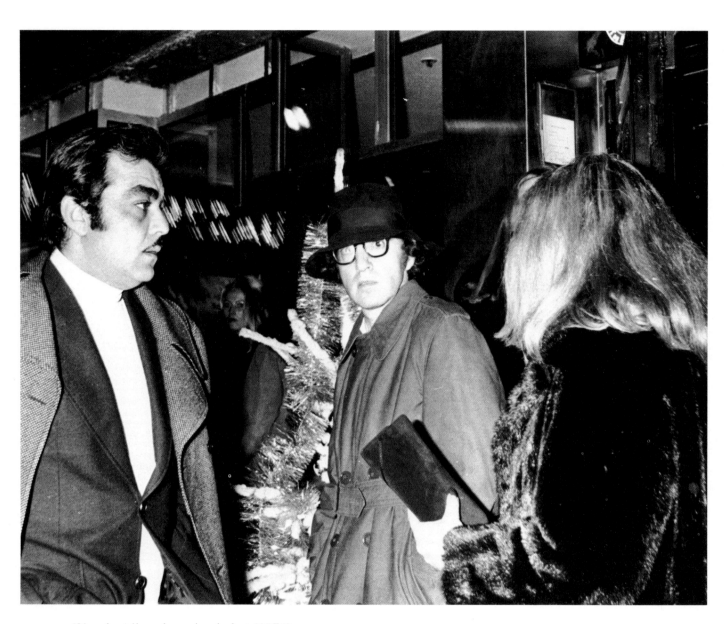

Woody Allen shopping in hat (1978)

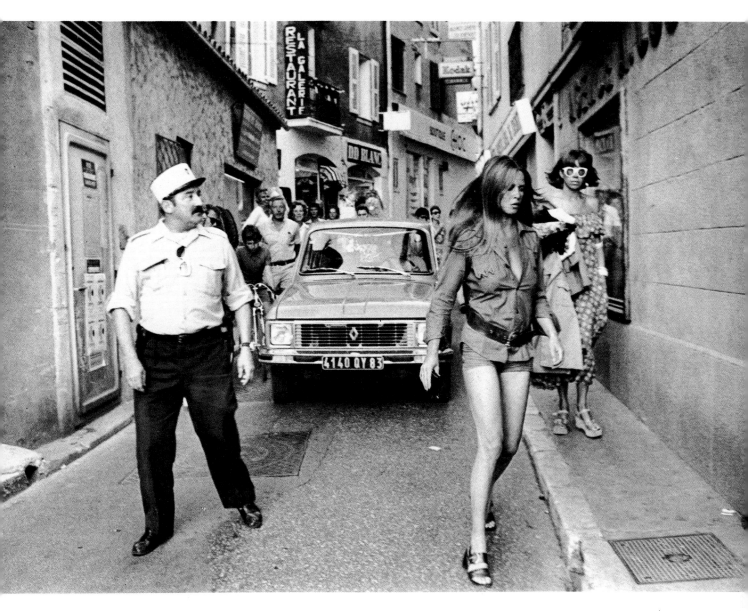

Brigitte Bardot shopping in shorts (1974)

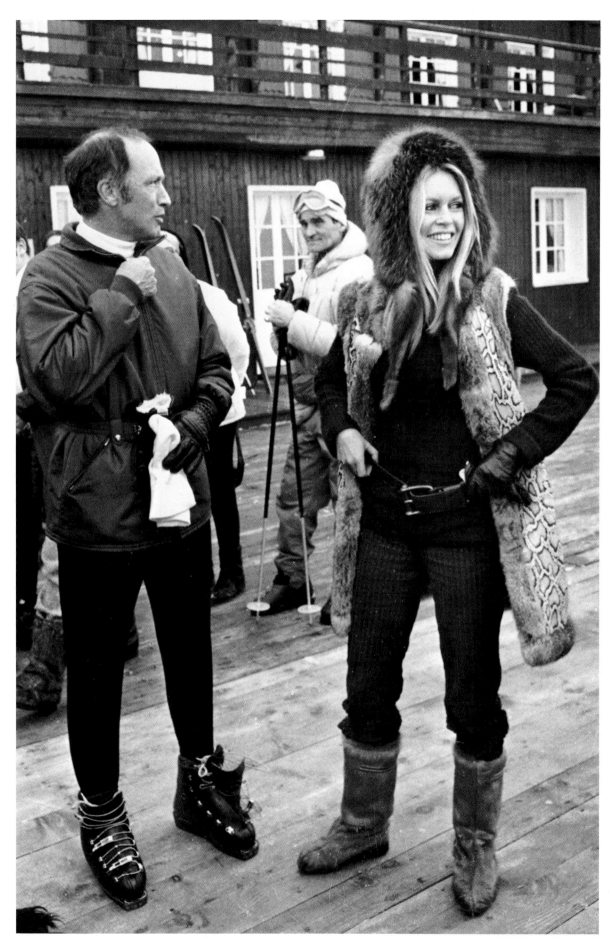

Trudeau meets Bardot on the slopes, Avoriaz (1973)

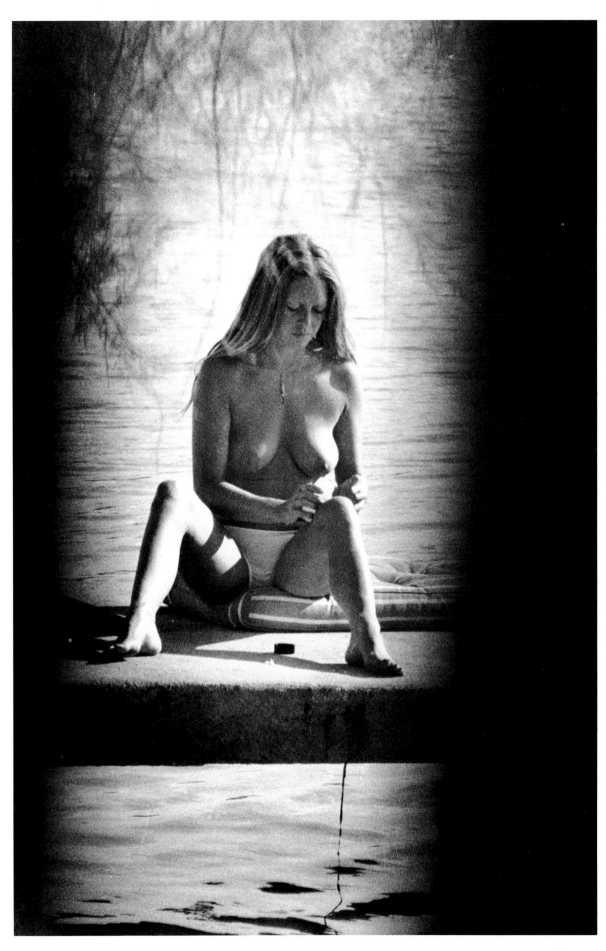

Bardot on her pier, Baies des Cannoubiers (1973)

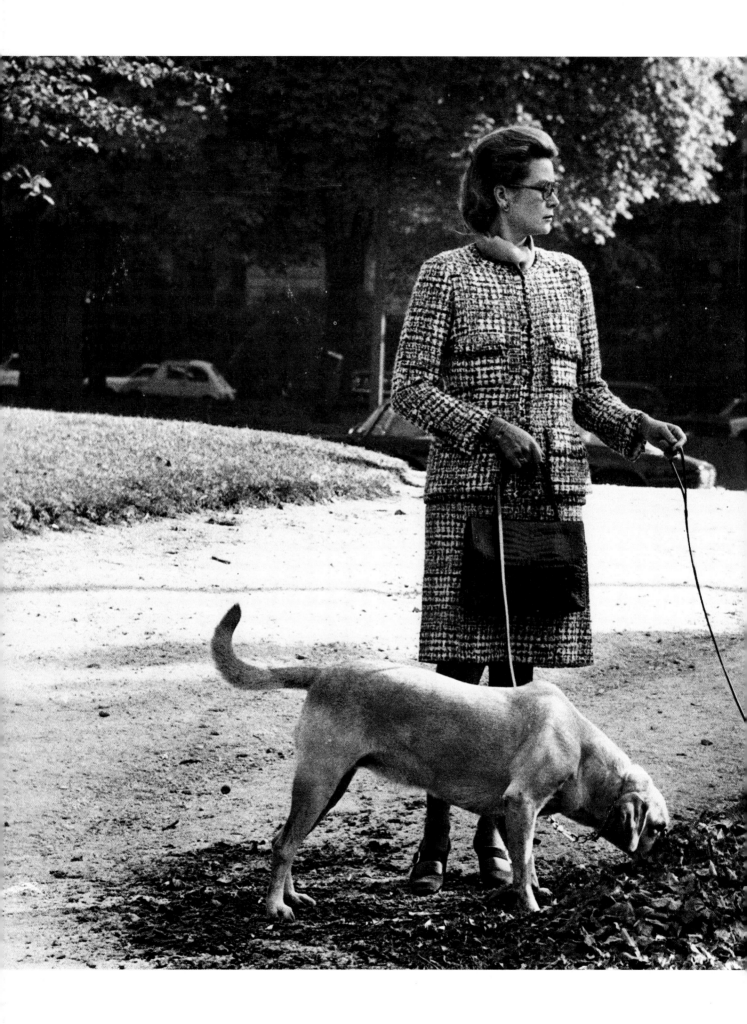

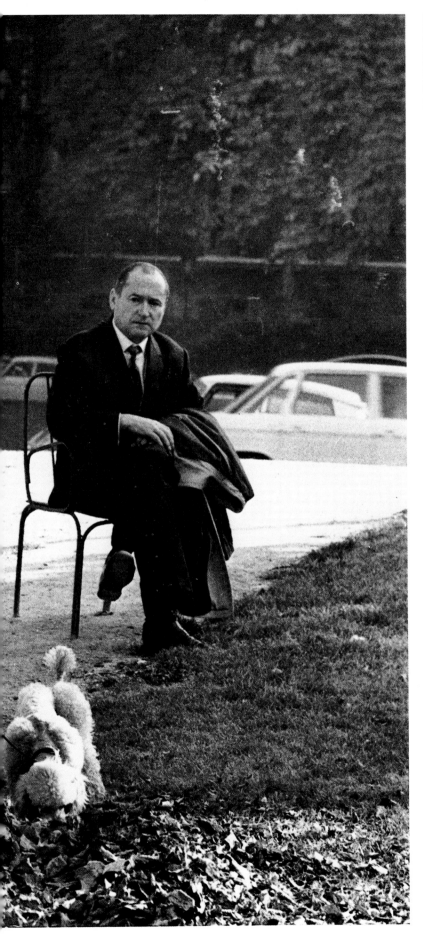

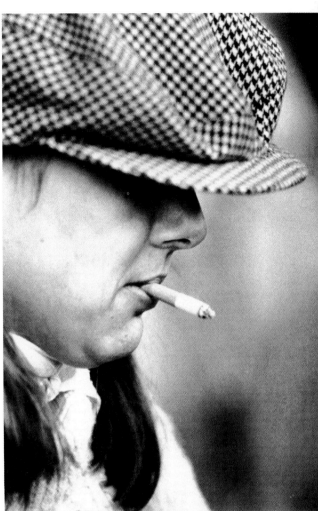

Princess Caroline while Philippe Junot plays football (1977)

Princess Grace of Monaco attends to her pets on Avenue Foch (1976)

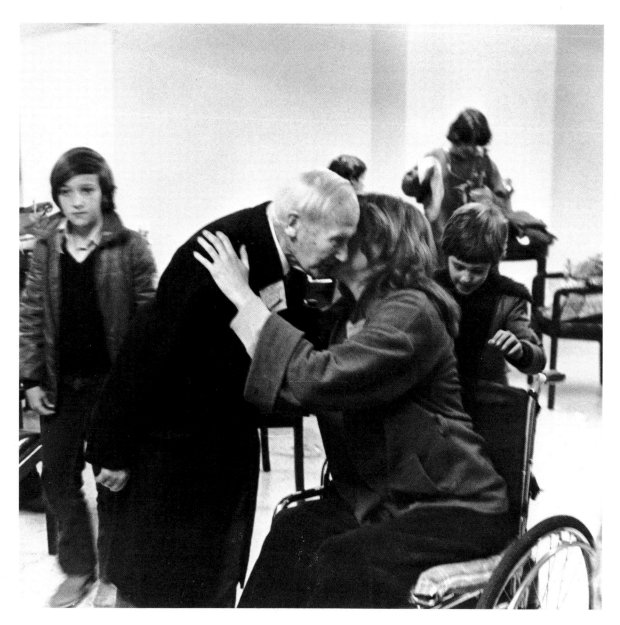

Miró on a theatre set with friends in Ibiza (1978)

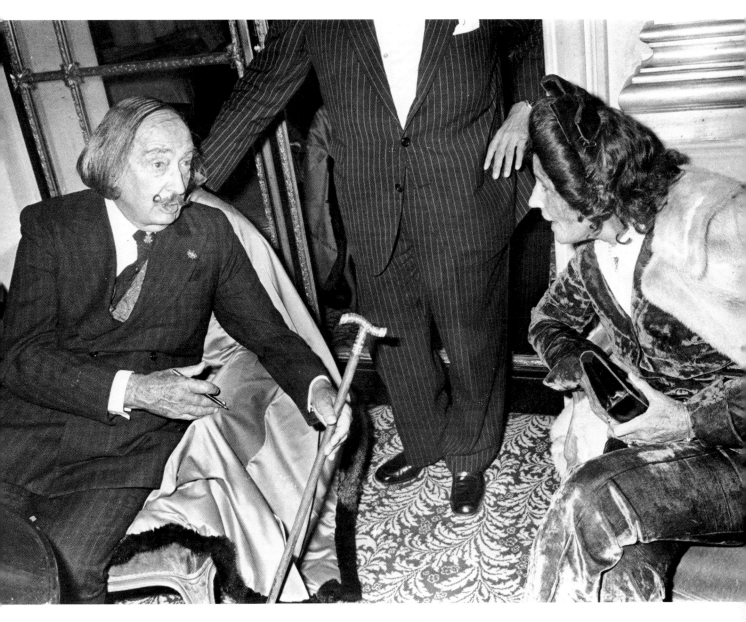

Salvador Dali and wife Galla at the Hôtel Meurice (1975)

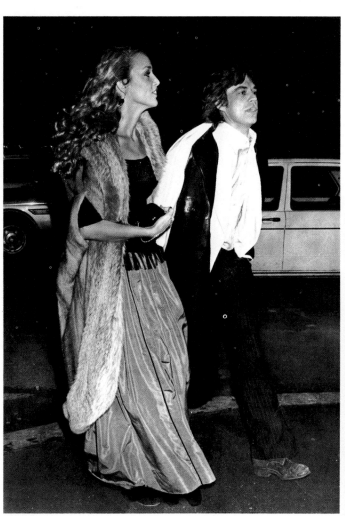

Mick Jagger, with Jerry Hall, meets a
photographer who knows judo (1978)

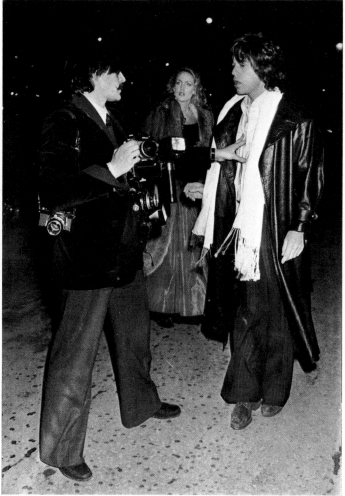

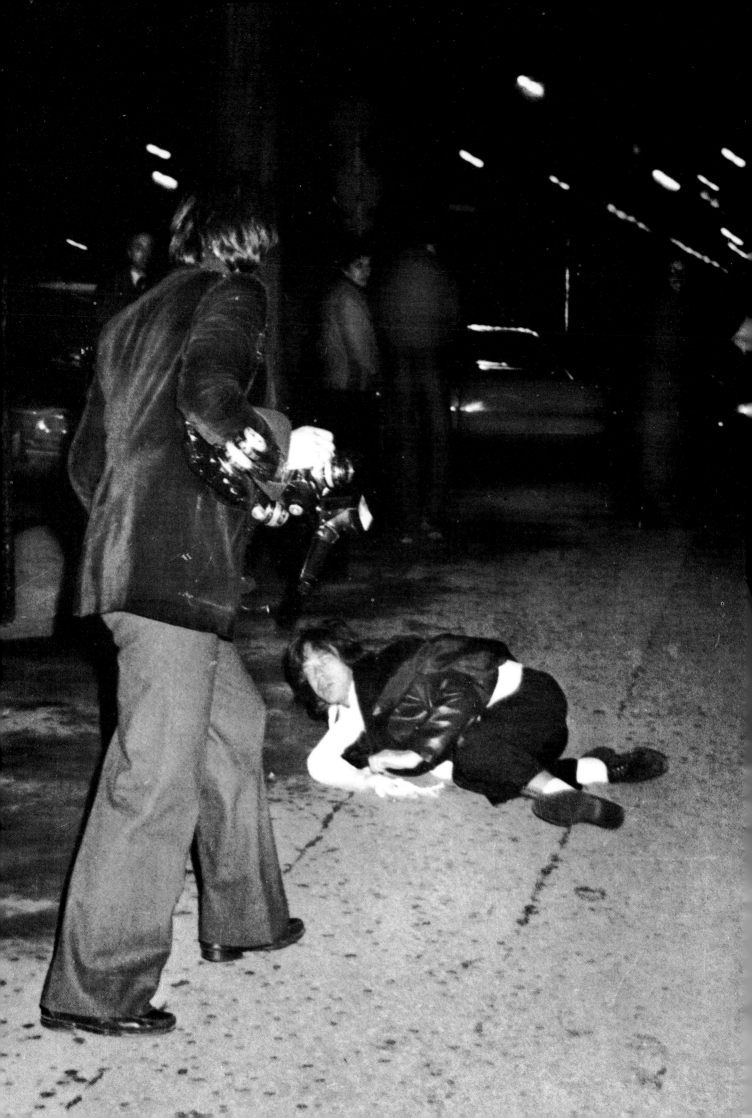

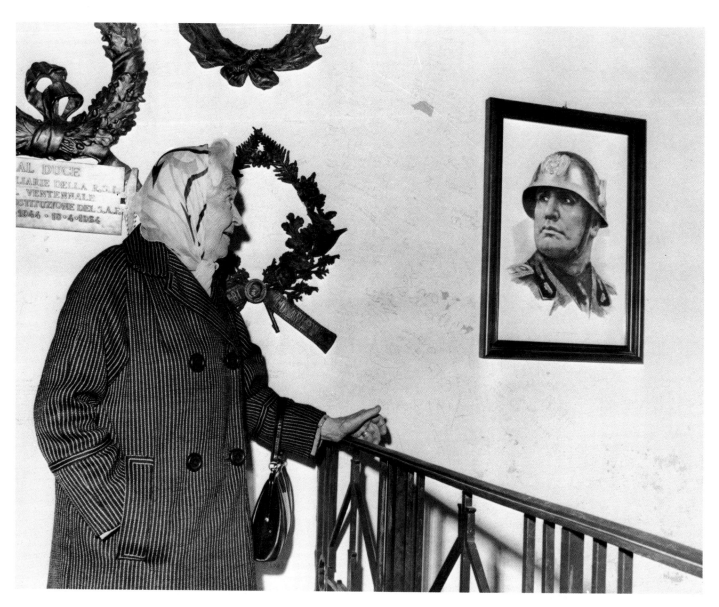

Wife's salute for the Duce, Milan (1976)

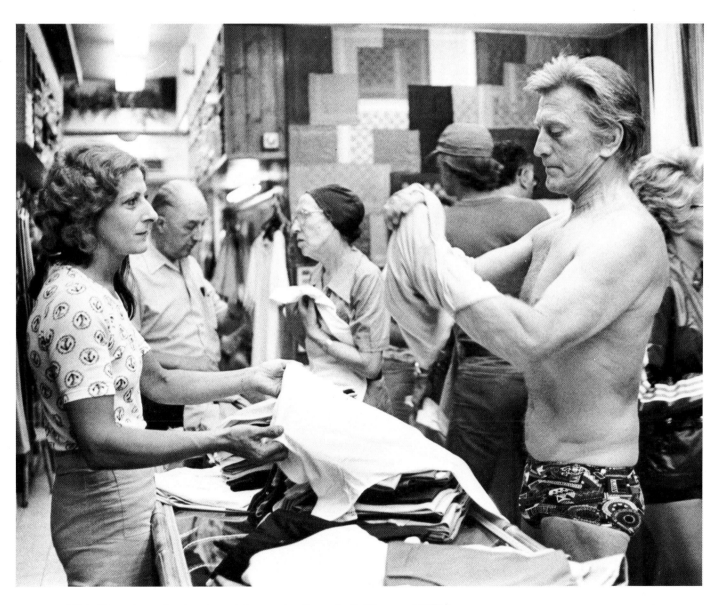

Kirk Douglas selects a tee-shirt on the Port de St Tropez (1976)

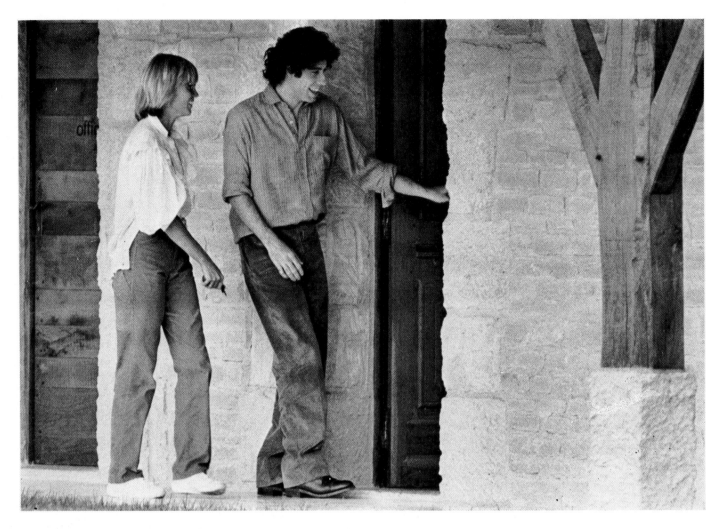

A country retreat, John Travolta and friend (1978)

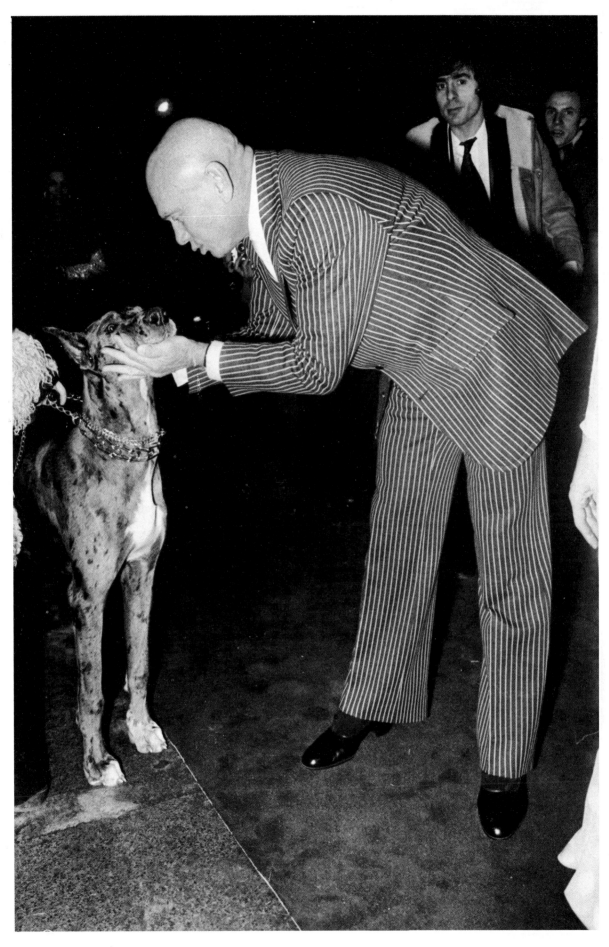

Yul Brynner, Paris (1977)

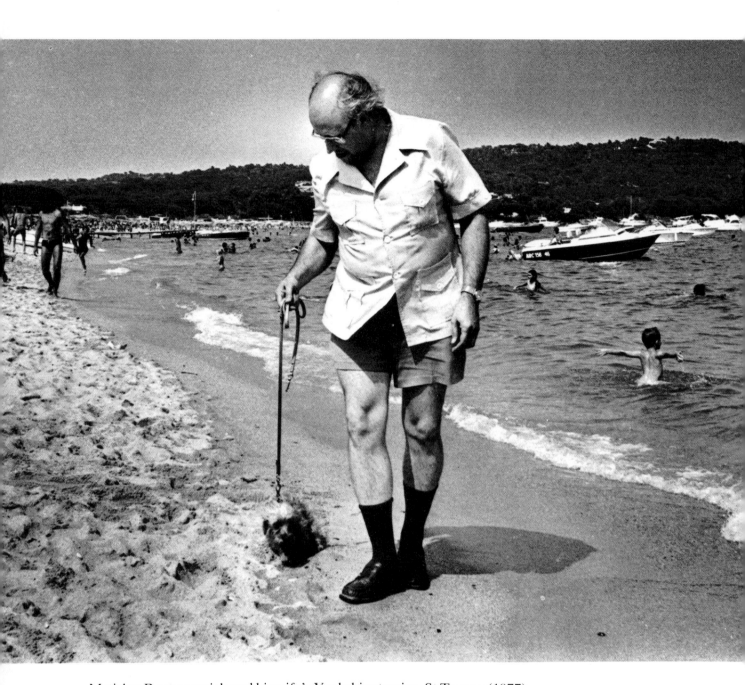

Mstislav Rostropovich and his wife's Yorkshire terrier, St Tropez (1977)

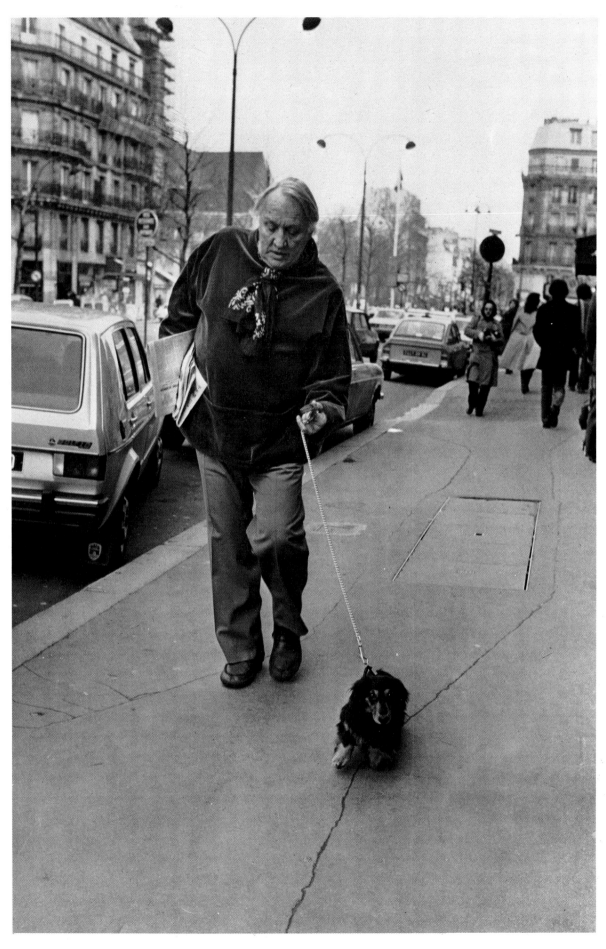

Joseph Losey's dog takes the lead, Rue St Germain (1976)

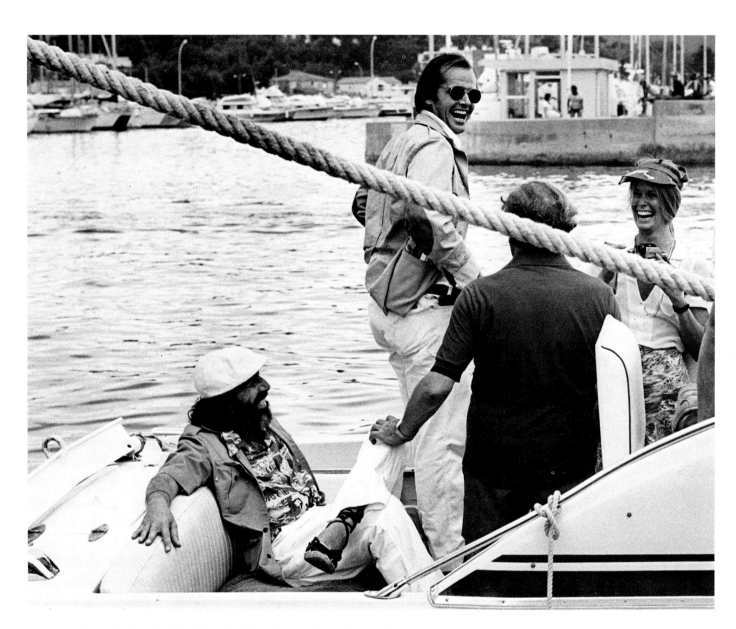

Lou Adler (left), his girlfriend and Sam Spiegel (back to camera), with Jack Nicholson demonstrating that he is a man of many parts, Port de St Tropez (1976)

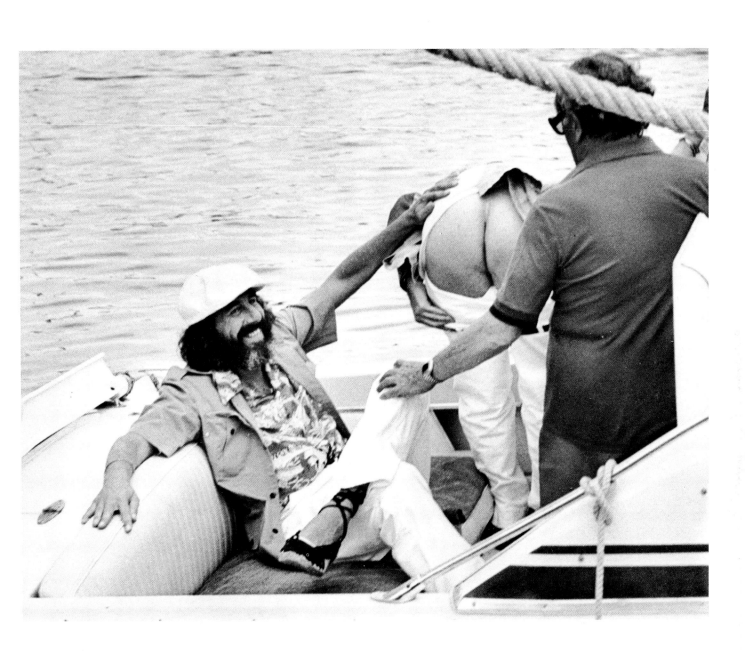

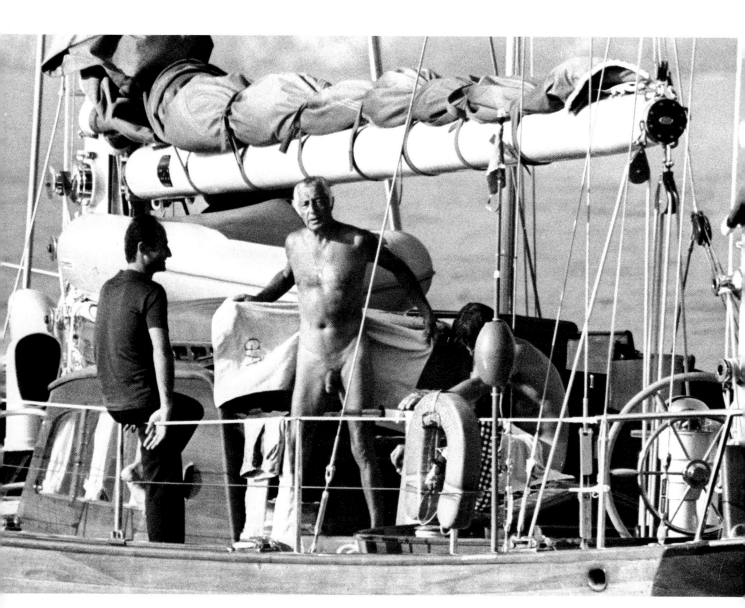

Giovanni Agnelli, St Jean Cap Ferrat (1978)

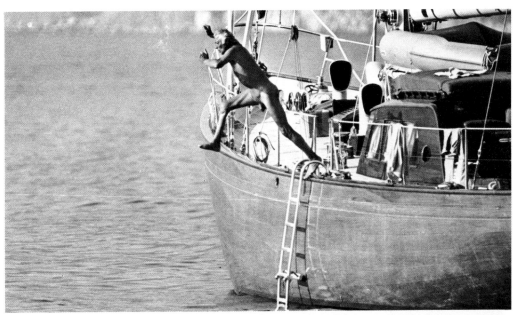

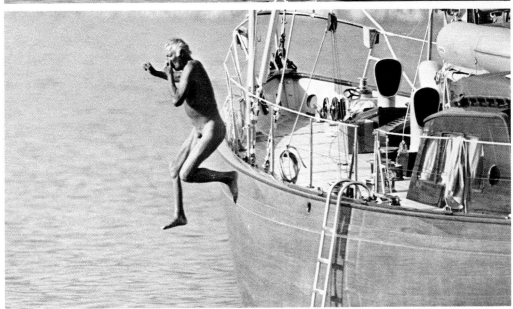

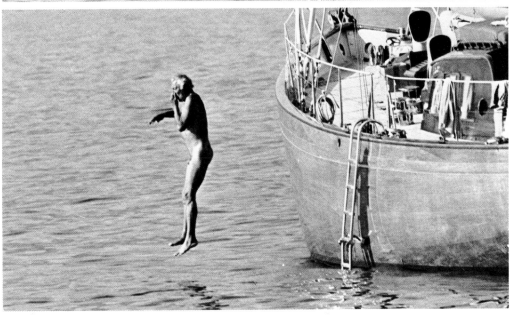

(On the following pages) Jacqueline Kennedy Onassis
greets photographers (1972)

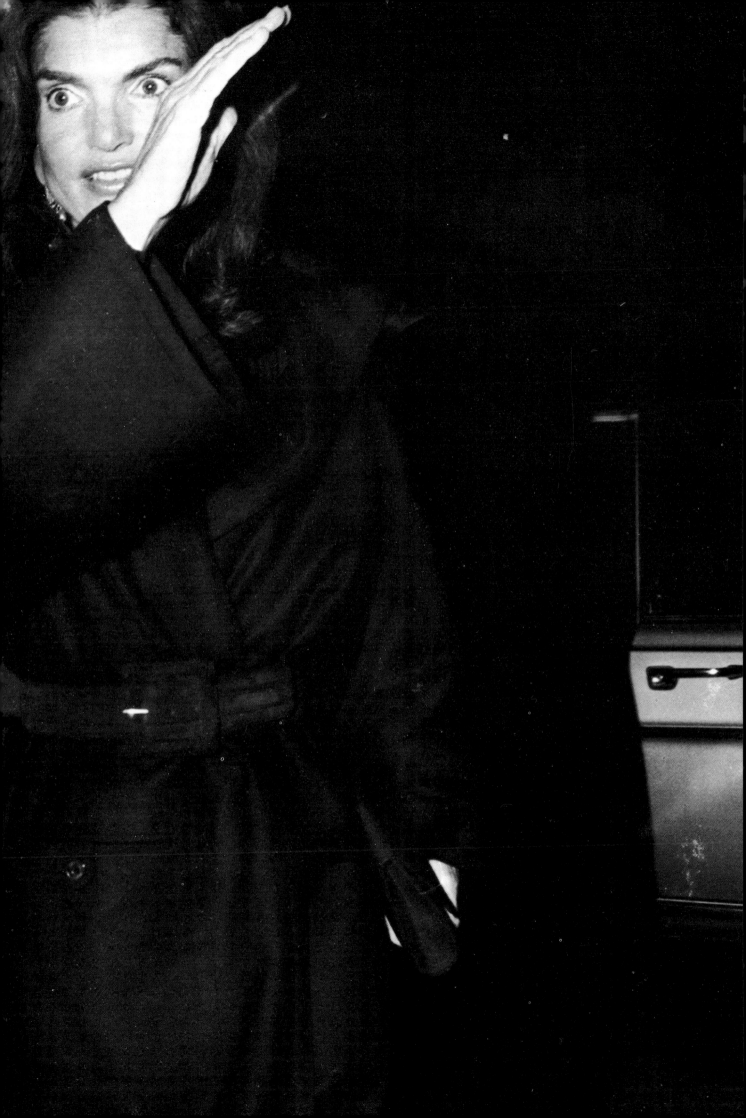

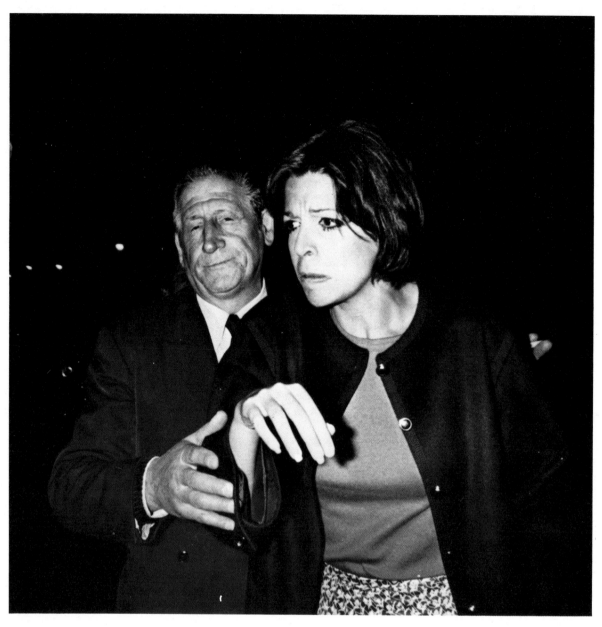

Reaching home on Avenue Foch, Christina
Onassis followed by Stavros Niarchos (1977)

Aristotle Onassis leaves a Paris nightclub (1972)

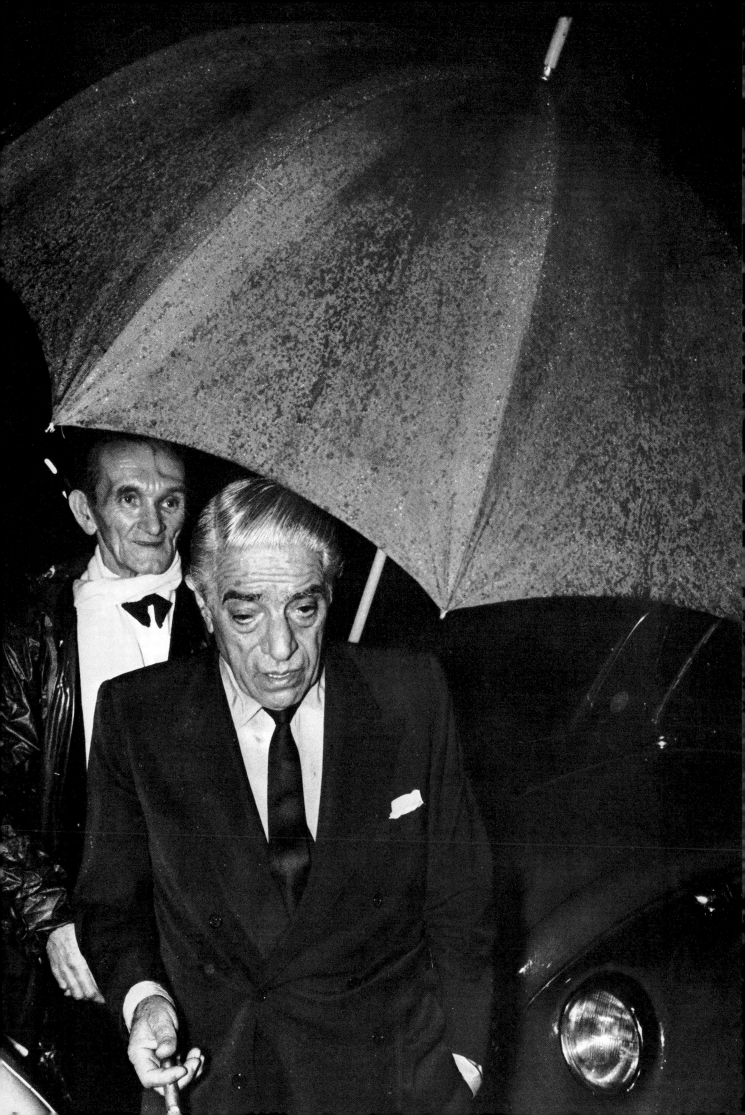

Edith Piaf with Gilbert Bécaud at the Olympia
Music Hall in Paris, shortly before her death
(1959)

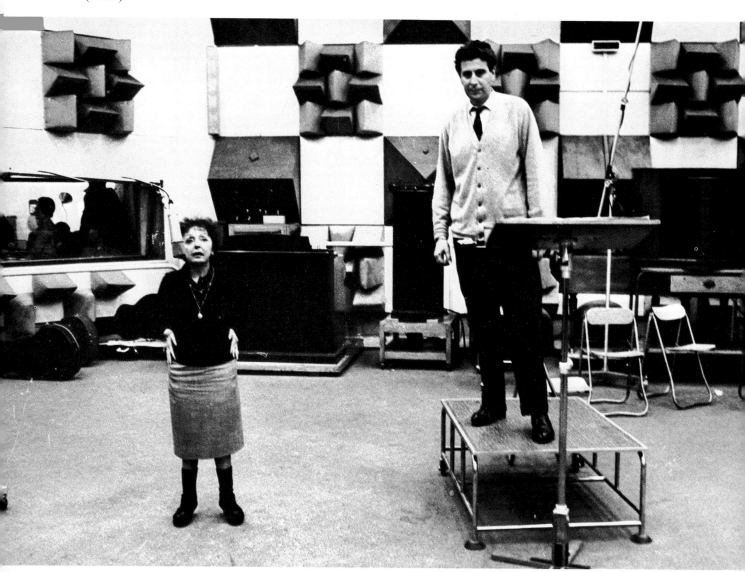

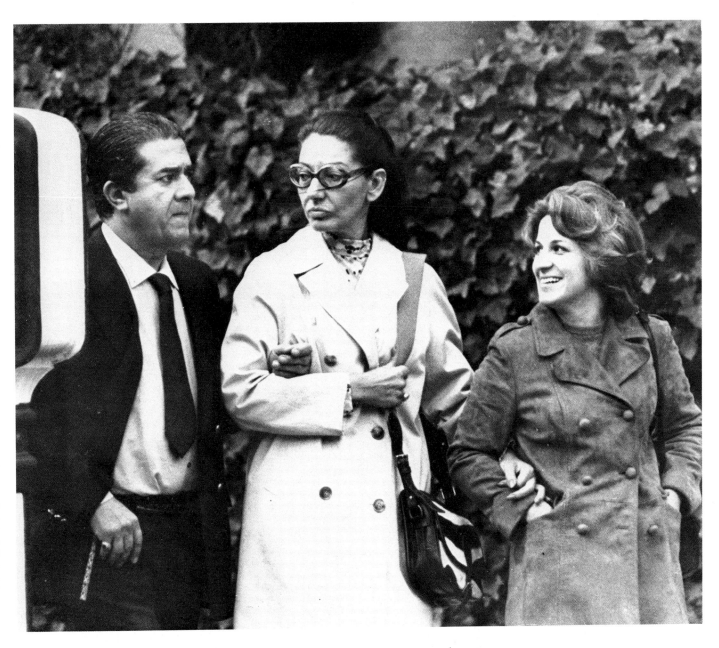

Maria Callas and Guiseppe Di Stefano, Théâtre des Champs Élysées (1974)

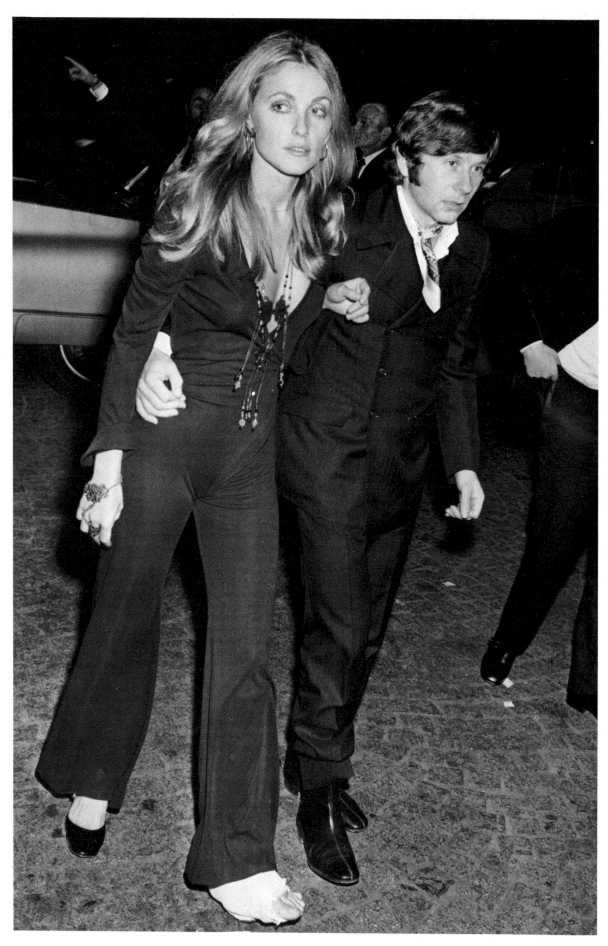

Sharon Tate and Roman Polanski for the last time in Paris (1967)

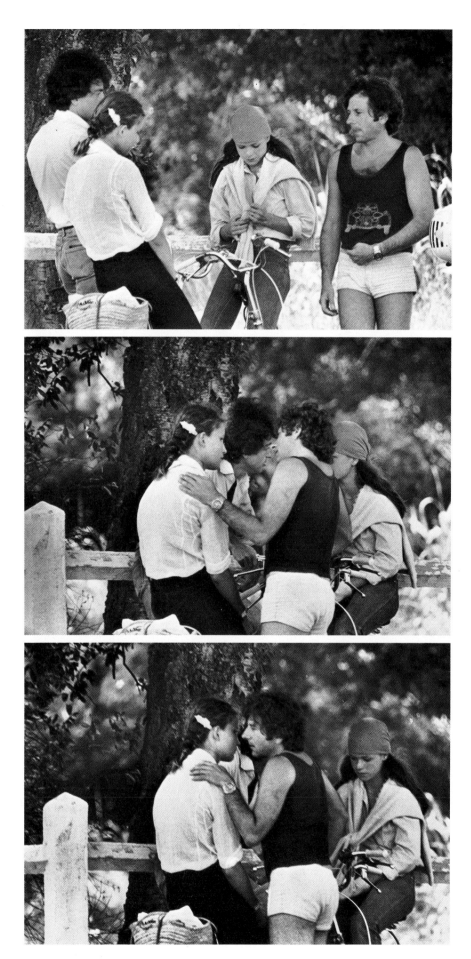

Polanski with teenage girls in St Tropez just after his trouble in California (1978)

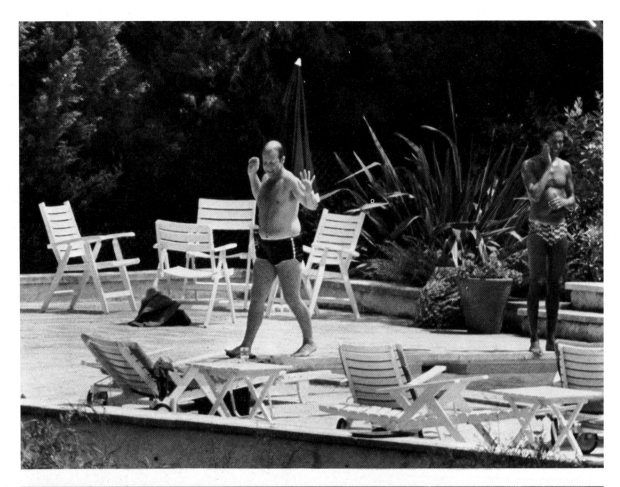

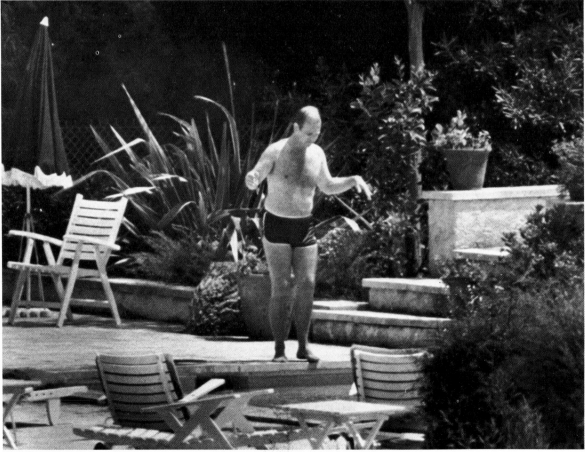

Elton at the pool, St Tropez (1979)

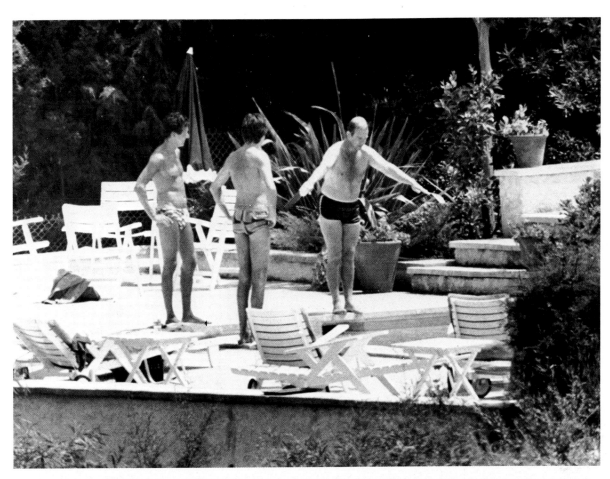

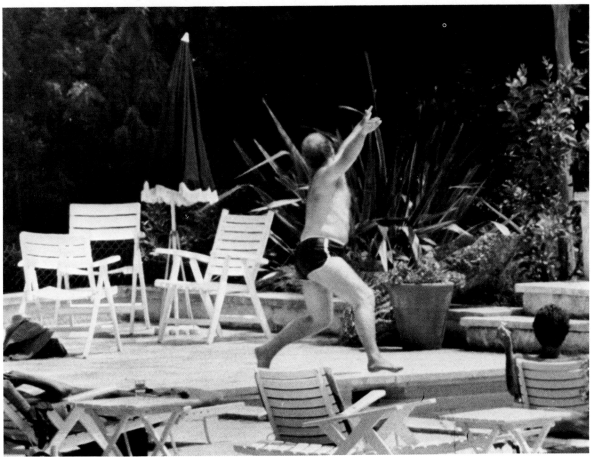

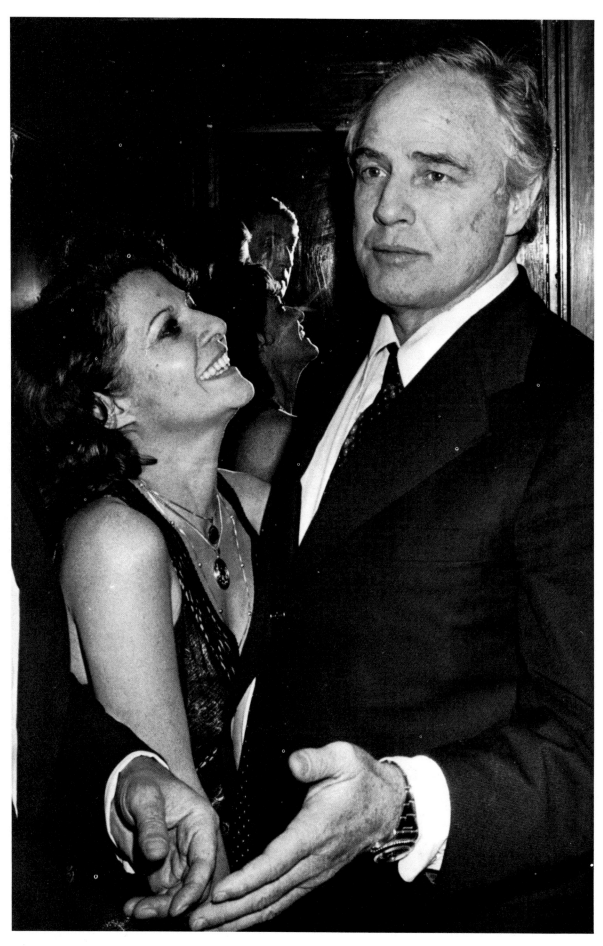

Marlon Brando with Turkish belly-dancer in a lift at the Hôtel Meurice (1975)

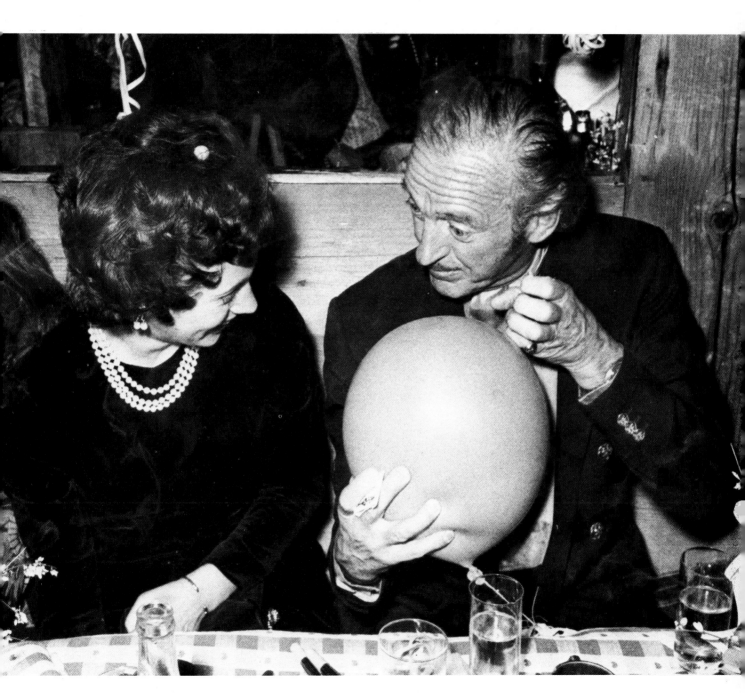

David Niven makes a point for Benedict of Denmark at 'Alcazar', Paris (1976)

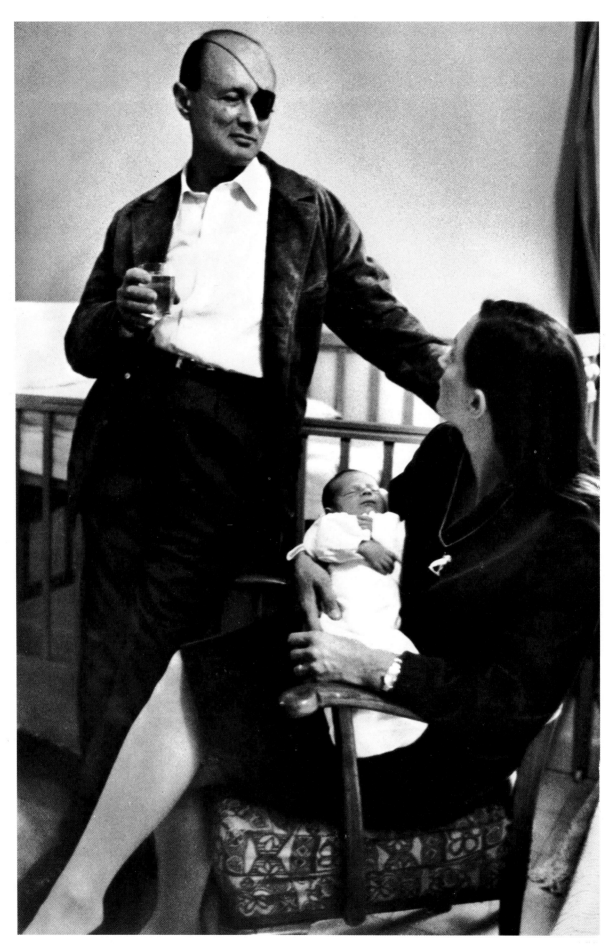

Moshe Dayan, daughter and grandson (1974)

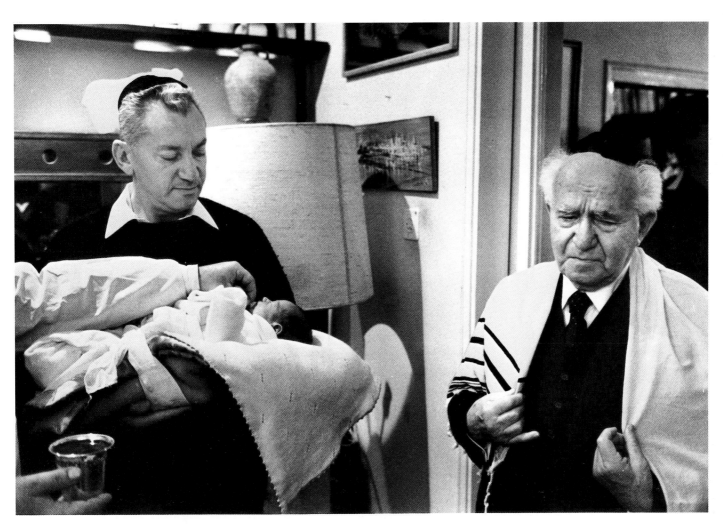

Ben Gurion attends the circumcision of Dayan's grandson, Tel Aviv (1966)

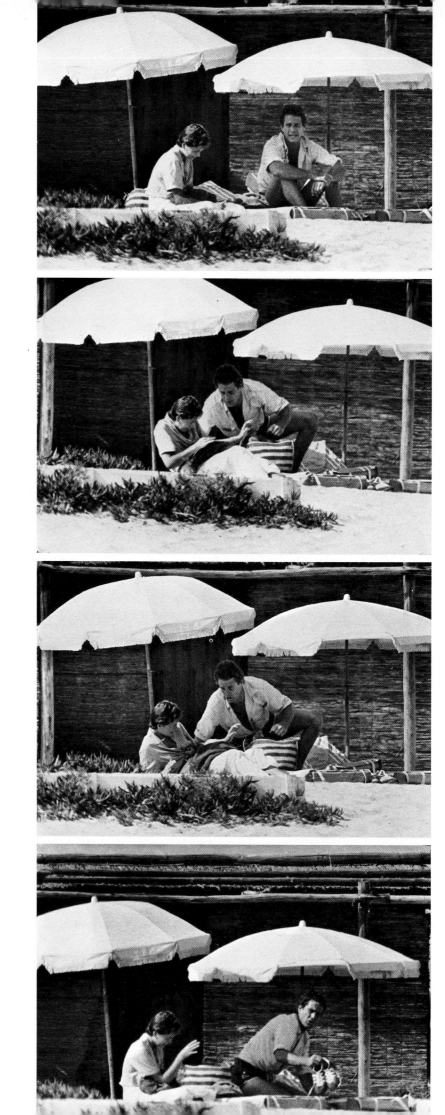

Arriving at a family agreement at 'Club 55'. St
Tropez, Ryan and Tatum O'Neal (1978)

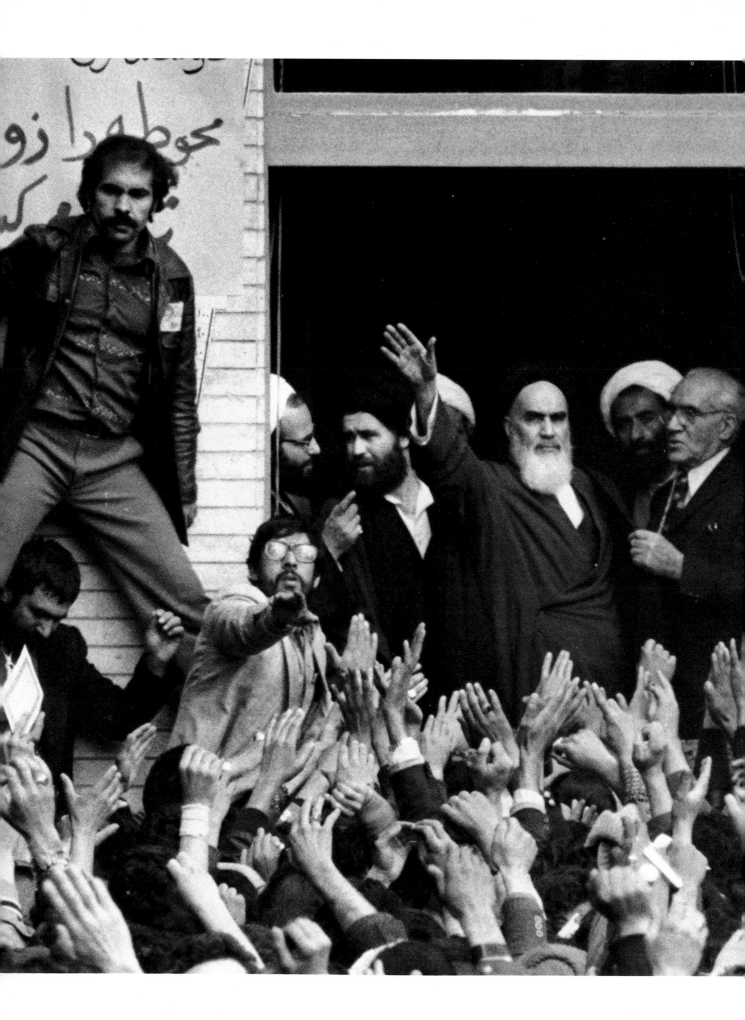

The Ayatollah in Tehran (1979)

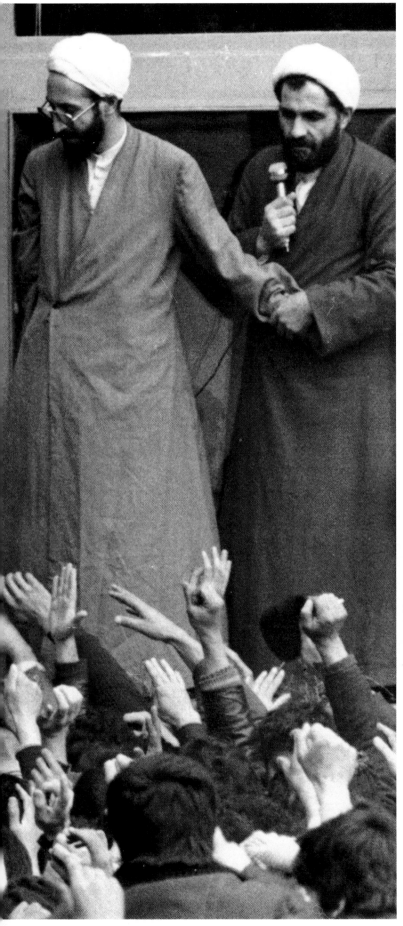

A moment before she throws her handbag at photographers, Marlene Dietrich at Charles de Gaulle Airport (1976)

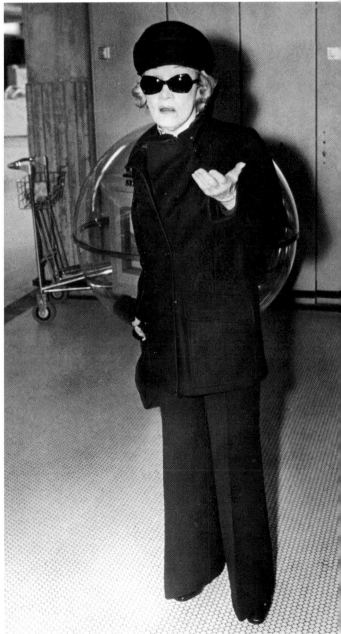

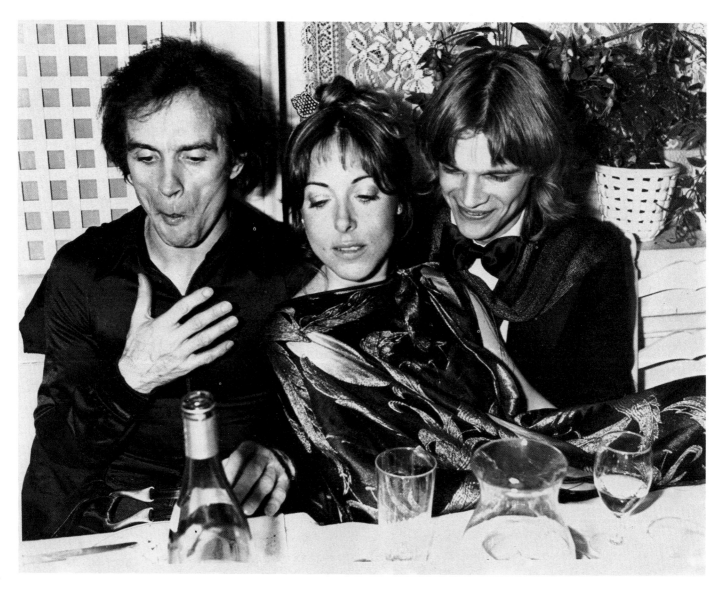

A cake is presented to Nureyev and colleagues, Paris (1977)

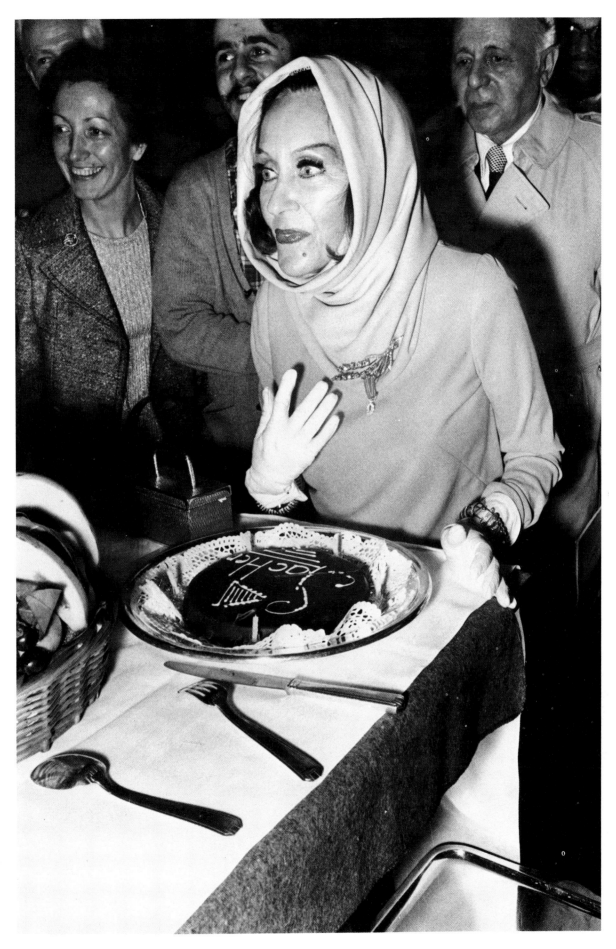

Happy Birthday. Gloria Swanson, Cannes (1973)

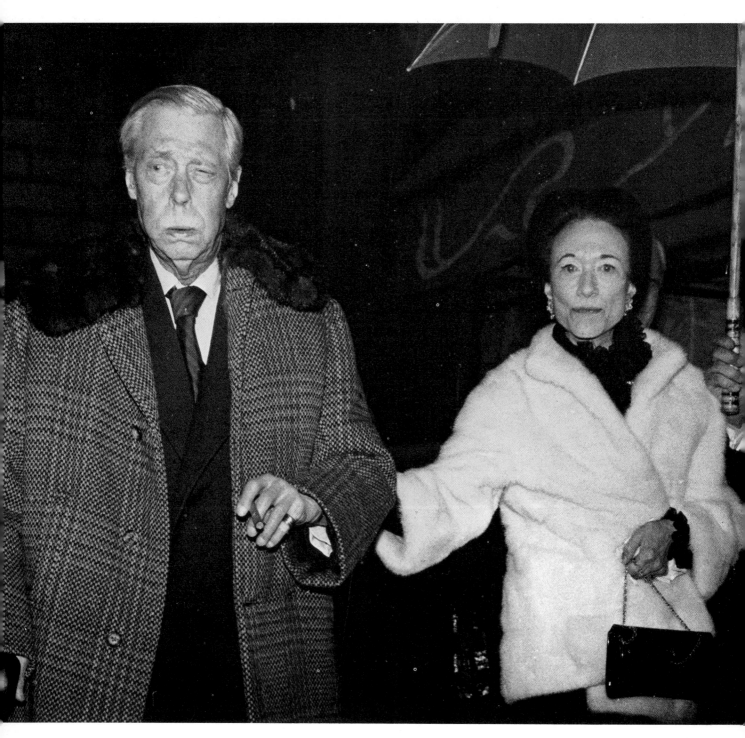

Having dined at 'Maxim's', the Duke and Duchess of Windsor (1974)

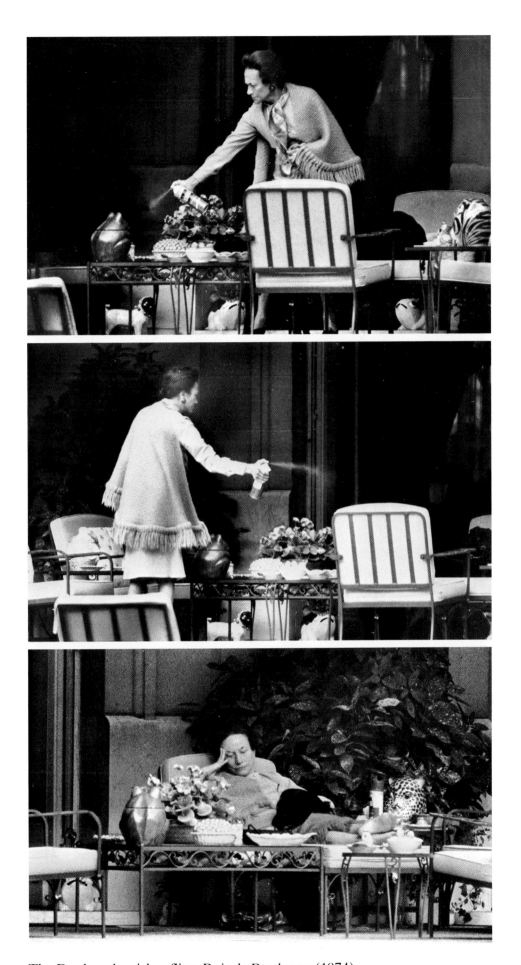

The Duchess banishes flies, Bois de Boulogne (1974)

(On the following pages) Chaplin a few days before he died. Wife Oona behind him, daughter Geraldine playing with her children, at his home, 'La Tour du Pin', in Vevey (1978)

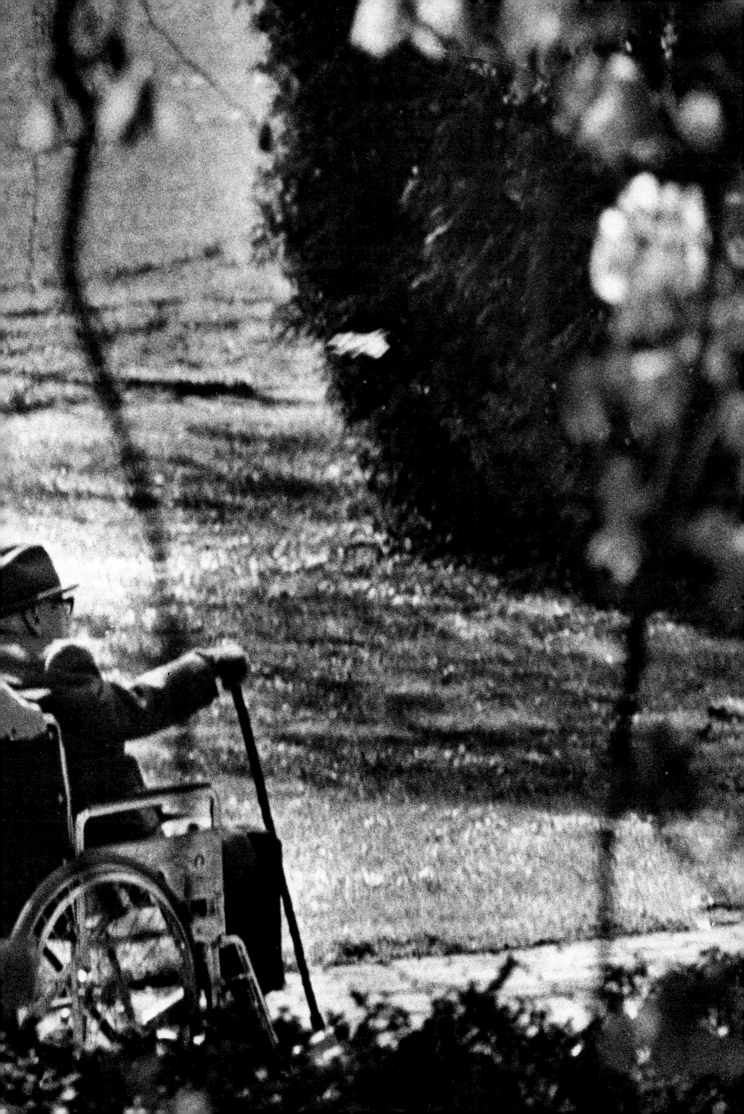

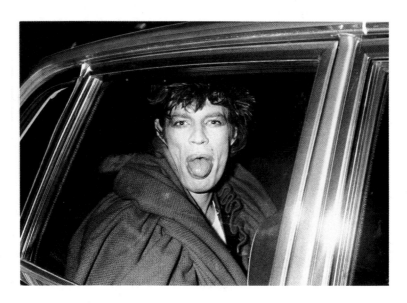

Mick's opinion